FORM AND CONTENT

FORM
AND CONTENT

photographs by
Algimantas Kezys, S.J.

Loyola University Press, Chicago, IL 60657

Dust jacket by Zina Morkunas

First Edition 1972
Second Edition 1979

Printed by Morkūnas Printing Company, Chicago, IL USA

Library of Congress Cataloging in Publication Data

Kezys, Algimantas.
 Form and content.

 Reprint of the 1972 ed. published by Morkunas, Chicago.
 Bibliography: p.
 1. Photography, Artistic. 2. Kezys, Algimantas.
I. Title.
TR654.K457 1979 779'.092'4 79-19505
ISBN O-8294-0280-2

CONTENTS

Foreword by *Hugh Edwards* v

Introduction by *Algimantas Kezys* vii

Publisher's Note xi

List of Photographs xii

FOREWORD

This, the second retrospective collection of photographs by Algimantas Kezys, S. J., is a strong and balanced pendant to the first which was published in 1966 by Loyola University Press. To return again and again to the former volume has always been a pleasure and satisfaction. In those pages was illustrated the odyssey of a young and exceptional talent which had been working in a number of European settings and had later moved on to residence in America. It seems that here in the United States was found an ideal milieu, inexhaustible in variety of content, large, and especially suited to the photographer's unusual aptitude for observation and selection. The book made one wish for a sequel which would continue and amplify the remarkable interpretation which had been begun of the American scene and subject matter, and now, five years later, it is here. It is a fine compensation for having waited. That it stimulates one to wish for and look forward to even more is only one of its characteristics as a successfully achieved pictorial work. With this it offers the assurance that ability is far from flagging, and there is no indication that resourcefulness will be forced to resort to the emergencies of repetition and pretentiousness.

For this book Father Kezys has written an essay which is admirable in that it states fully, simply, and with convincing vehemence, his attitudes, his position, and the indivisible relationship of his work to himself. It is not often that

photographers have done this in language that is so explicit and sincere. The breadth of viewpoint and generous acceptance of the many ways of photographic expression do not compromise the strength of the declaration of individual aims and intentions. It leaves little to be said by an outsider and may be compared to an unobtrusive cyclorama which acts as background and adds light, contour, and dimension to the sequence of imagery before you.

When we turn to the photographs themselves the photographer's predilection for form over content does not preclude appreciation of the wealth of visual material with its infinite suggestions and the revelations which animate each subject. Instead, it gives all these qualities strength, accentuates them, and brings them into focus. We witness here what the eye may see, but what lies before us on the pages of reproductions are not transcriptions of realities as our eyes alone would see them. Another individuality than ours, with an instrument of precision, has chosen these subjects before us, and marvelous transformations have taken place so that they are revealed to us with finer exactitude and a greater variety of particularities than we could have noticed unaided. The objective was not the imitation of reality, but a special statement of it in the terms of form, of reason and good sense which, as Racine said, have been the same in all ages, and by which it is possible to express anything.

As we progress through the book and photograph succeeds photograph, it becomes large with its excellent exposition of the differences and variations which exist unnoticed in the life around us. Design and pattern never enslave material, external ideologies do not intrude, as happen with so many photographers. Form and content complement one another in balance and harmony, and their unity presents a rich experience of vision.

Hugh Edwards

Hugh Edwards was Curator of Photography at the Art Institute of Chicago from 1959 until his retirement in 1970.

INTRODUCTION

I believe the camera is a mechanical tool for communication between individuals. The process of photographic communication begins with the photographer's inner self. It continues through the mechanics of photography, which act as transmitters of his thoughts, feelings and vision to another individual.

The photographer's inner eye has as much to do with a photograph that communicates, as his other eye which actually looks through the viewfinder. Photography is not what's important. It's seeing. The camera, film, even pictures are not important. What is important is the fact that you see and that you make others see by means of your photographs.

All this proves to me, that there are not different kinds of photography, but that there are different ways of seeing and feeling about the world, which in turn produce "kinds" in the photographic medium. And so, a personal style in photography is possible despite the inherent objectivity of the medium. But the momentum for it must generate from within. Personal style cannot be imposed. It can probably be cultivated, striven for and finally achieved. But its blueprint must be present within the confines of one's own mental setup. The secret of developing a personal style in photography is a matter of discovering oneself.

Photography as a technique offers a number of possible ways of expressing one's thoughts and feelings on paper. A photographer has to discover which of the ways is best for him. There are, for

instance, experimenters who create images primarily in the dark room. The creative moment for them is after, not before, the negative has been made. They are not just printers from existing negatives but creators of entirely new images. They are not takers but makers of pictures. I do not think anybody should dispute the validity of this approach to photography. The process is a valid one. It has proved itself valid in a number of cases. But again the validity here depends on faithfulness to one's own creative setup. I may produce only ordinary negatives, but if I begin to get ideas of how to transform them into extraordinary images after they have been taken, so much the better. Then I should consider the post-negative stage as my most sacred moment because it is here that the inspiration takes over.

On the other hand there are those who believe that good pictures must start with an idea. These are the pre-visualisation people who produce marvelous photographs on their drawing boards. The actual shooting of the picture and making of the print is nothing more than a technical execution of a previously thought-out plan. They know exactly how the picture ought to come out even before they load their camera with film. This is where their creativity is at its best. Good for them. This is their moment of glory and they should recognize it as such.

Neither of these two approaches to photography is for me. I have discovered that my pre-visualisation powers are completely dormant, and that my post-visualisation dexterity is nonexistent. I can't be either an art director who tells photographers or himself what to shoot, nor a lab technician who produces marvels even from the most ordinary negative material. From my own observation of myself I know that my "moment of glory" is the moment of seeing and discovering. For me this is the crucial point at which pictures are made or unmade.

I do not put too much stress on the printing session because a mediocre negative produces a mediocre picture, and that is that. And I try to stay away from picture ideas because they tend to kill my pictures. I work much better the other way around: I start with a picture that satisfies my inner being and then hope that it will produce a similar response in those who will look at it — be it ideas, feelings, or what have you.

I hold in great esteem photographers who achieve perfection in their work by combining great content in perfect form. Great content in perfect form — this is the objective of photography as

an art form. This is what all photography should aim at and be concerned with — that is, if we speak of it *in abstracto*. But photography never exists without photographers. It is the man behind the camera that has to be taken into account. And it is here that we find diversification of aims, each according to his kind. The judgment of what is good and what is better in photography should be rendered only after recognition of the photographer's own prerogative to determine what is best for him. Some by nature are designers, others are reporters, still others interpreters. Let them be so and be happy in what they are. And let them change only when there is an inner need to change and not before.

In my own work I tend to emphasize form to the detriment of content. I am not a war photographer, nor do I chase important events or important personalities. Explicit social comment does not draw me either.

A friend of mine who was a professional magazine photographer told me that the thing for him was picture stories. On a single story he could shoot endless film. He boasted once of making at least five exposures of a man bringing a lighted match to the cigarette in his mouth. The worst waste of time, he said, was between rolls, changing film. The pictures he produced were much sought after by editors and publishers. The subject was covered from every possible angle, and there were lots of pictures to choose from.

I would really have to force myself to do this. I believe that documentary photography is a valid art form for those who feel at home with it. They have a mentality which makes them produce original, vitally alive and exciting work in this particular area. But it is not valid for those whose mental mechanism works differently.

Suppose you asked me to cover an important event. Where should I start? Should I get an editor who would outline the main points to be covered? Logic says that this is the way it should be done. But is art logic? For me a strictly documentary picture story is out. To do a comprehensive story means that, although one does not want to, one must shoot. And I would like to eliminate snapshots from my photography as much as possible. For me it is easier to photograph an insignificant detail, if it is esthetically rewarding than a V. I. P. if he happens to be in a meaningless form context. My picture stories are, at best, fragments in a very loose framework where points of main interest may be conspicuously missing. I know that this approach has real disadvantages and

dangers. It disregards life which is supposed to be bigger than art. And I have heard about the brutal and unsentimental fact that one who photographs for art may never make it, while another who simply records life may do just that — create art. Photography of its very nature is a means of communication which uses the real world as a medium. Psychological undercurrents should be thought of as suspect. There is a possibility that a viewer might experience more of these undercurrents when looking at a photograph, the less attention the photographer paid to them when he took the picture and concentrated more on the real. My suspicion is that a photographer who strives to create "art" in his photographs may miss the target completely, while another whose objective is more modest — i.e., to record an event — may turn out to be the real artist of the medium. He recognized beauty and meaning in situations of real life and was able to record it convincingly on film.

So these are the facts. But I think there is more to be taken into consideration here than just cold facts. The facts may tell you that a reporting photographer has a better chance of survival as an artist than any other kind of photographer. He has the great content ready made, and if he hits on the perfect form, he has it made. One can admire the work of these men. And yet if one knows that their line is not for him, he must travel another road — his own road even though this road is a more modest one. There is no other way but your own. I am a single picture photographer. Form attracts me more than content. Content plays a secondary role. It does not matter to me whether the picture is of a man, or of a bird, or of a rock. Each subject gets equal attention and is equally exciting if it happens to be in a meaningful form. A disadvantage? Yes. A danger? And possibly a trap. But one should never be jealous in the race of the arts. The world is so full of beauty and meaning that there is enough of it for everybody — to explore, to relish and to transform, each in his own way. My way is that of a photographer who gets excited (in a tourist fashion) by sunsets, shadows, reflections and sometimes by faces. There is nothing to prove, nothing to boast about, except the plain fact that a spark of beauty has been found in some remote corner of the globe.

Algimantas Kezys, S.J.

NOTE FROM THE PUBLISHER

Algimantas Kezys is a man with a vision and a camera, and his camera gives us an opportunity to see as he sees. We see what he sees every day; but that deeper vision, the seeing with the inner eye, is what we miss. He sees the eloquent form, the strong line, the bold shadow, the delicate detail, the stark contrast of line and curve. He sees the symmetry, measure, and balance of form in the ordinary things around us. He has a vision of form that is delight to the eye and a satisfaction to the mind. Contemplation is what we are talking about here, pure vision, delightful seeing. We do not have to ask questions, reason, puzzle, or discourse. It is enough to behold, to be quiet, to admire. And from this seeing, our own vision is enriched, our own spirit is enlarged.

Loyola University Press has published many of Algimantas Kezys' photographs in many formats, in many books. We are proud to present his work in this new edition of *Form and Content*.

George A. Lane, S.J.

Associate Director,
Loyola University Press, Chicago

LIST OF PHOTOGRAPHS

1. Portrait. 1968.
2. Knott's Berry Farm. Buena Park, California. 1966.
3. Monaco Pavilion. Expo '67, Montreal, Quebec. 1967.
4. In an Elevator. Expo '67, Montreal, Quebec. 1966.
5. Pond at Knott's Berry Farm. Buena Park, California. 1966.
6. Bridge. Pinellas Bayway, Florida. 1967.
7. Monorail Tracks. Expo '67, Montreal, Quebec. 1967.
8. Snow-Fence. Washington, D.C. 1969.
9. Guard-Rail and Flowers. Tampa, Florida. 1967.
10. Bridge of the Isles. Expo '67, Montreal, Quebec. 1967.
11. Tourists at Fort Macleod. Fort Macleod, Alberta. 1966.
12. Parking Lot. Simon Fraser University, Vancouver, British Columbia. 1966.
13. Among Park Benches. Bellville, Illinois. 1969.
14. Shadow Sets and a Pair. Pioneer Town, Montana. 1966.
15. Chiseled Blocks. Expo '67, Montreal, Quebec. 1967.
16. La Ronde. Expo '67, Montreal, Quebec. 1967.
17. Pulp and Paper Pavilion, Expo '67. Montreal, Quebec. 1967.
18. Pilgrim Monument (interior view). Provincetown, Massachusetts. 1969.
19. Mist below Niagara Falls. Niagara Falls, New York. 1968.
20. University Stadium. Mexico City, Mexico. 1968.
21. Seagull over unfrozen Area of Niagara Falls River. Niagara Falls, New York. 1968.
22. In a City Square. Toronto, Ontario. 1969.
23. Shadows of a Fence. Tampa, Florida. 1967.
24. Outdoor Theatre. Expo '67, Montreal, Quebec. 1967.
25. Abandoned Pier. Provincetown, Massachusetts. 1969.
26. In Central Park. Manhattan, New York. 1969.
27. Stairs from Mexican Backyard. Mexico City, Mexico. 1968.
28. Mexican Window Pattern. Mexico City, Mexico. 1968.

29. Stage Construction. Expo '67, Montreal, Quebec. 1967.
30. Entrance Gate. Old Niagara Fort, New York. 1968.
31. Garage Door. New York City, New York. 1968.
32. String on a Wooden Floor. Rockaway Beach, New York. 1968.
33. Details of a Fence. Chicago, Illinois. 1966.
34. Mammoth Hot Springs. Yellowstone National Park, Wyoming. 1966.
35. Mammoth Hot Springs. Yellowstone National Park, Wyoming. 1966.
36. Ruins in the "Plaza Tres Culturas". Mexico City, Mexico. 1968.
37. Crest of the Falls. Niagara Falls, New York. 1969.
38. A Path near Bahai Temple. Evanston, Illinois. 1968.
39. Lake Michigan. Michiana Shores, Michigan. 1967.
40. Swimming Pool in Schenley Park. Pittsburgh, Pennsylvania. 1969.
41. A Grille and Its Reflection. Flusing Meadow Park, Flushing, New York. 1969.
42. Solitary Boat. Provincetown, Massachusetts. 1969.
43. Reflections in Turbulent Waters. San Antonio, Texas. 1968.
44. Foaming Sea. Pallisades State Park Beach, Santa Monica, California. 1966.
45. Fishing Barges. Provincetown, Massachusetts. 1969.
46. The Sun's Reflection on a Pond. Mexico City, Mexico. 1968.
47. Pavilion of the City (interior view). Expo '67, Montreal, Quebec. 1967.
48. Skyscraper Reflected on Water. Central Park, Manhattan, New York. 1969.
49. Window Patterned by Snow and Time. Chicago, Illinois. 1967.
50. In a Shattered Mirror. Chicago, Illinois. 1968.
51. Children and Shadows. Camp Rakas, Custer, Michigan. 1966.
52. Facing the Canadian Ledge of the Falls at Sunset. Niagara Falls, New York. 1969.
53. Portrait of a Boy. New York City, New York. 1969.
54. Pigeons. Lincoln Park Zoo, Chicago, Illinois. 1967.
55. Caged Bird. San Antonio Zoo, San Antonio, Texas. 1968.
56. Hemisfair '68. San Antonio, Texas. 1968.
57. The Door. Chicago, Illinois. 1967.
58. Shuttered Windows. Old Town, Chicago, Illinois 1967.
59. Train Car. Allaire, New Jersey. 1969.
60. Curtained Door. Wilkes-Barre, Pennsylvania. 1968.
61. Tattered Hangings. Allaire, New Jersey. 1969.
62. Sun Streaks on a Steel Wall. Gateway Arch, St. Louis, Missouri. 1969.
63. Partitions. Lincoln Park Zoo, Chicago, Illinois. 1967.
64. End of a Freight Car. Illinois Central, Chicago, Illinois. 1967.

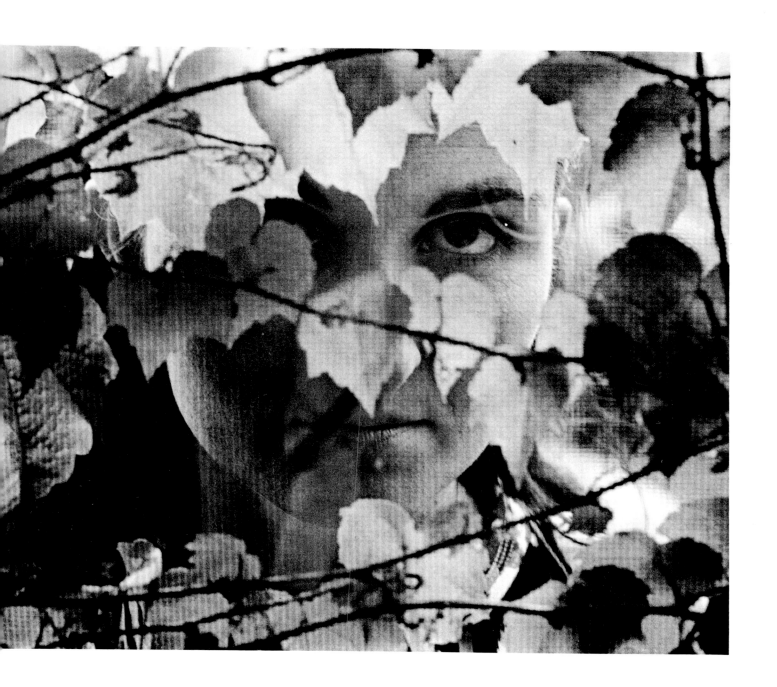

2

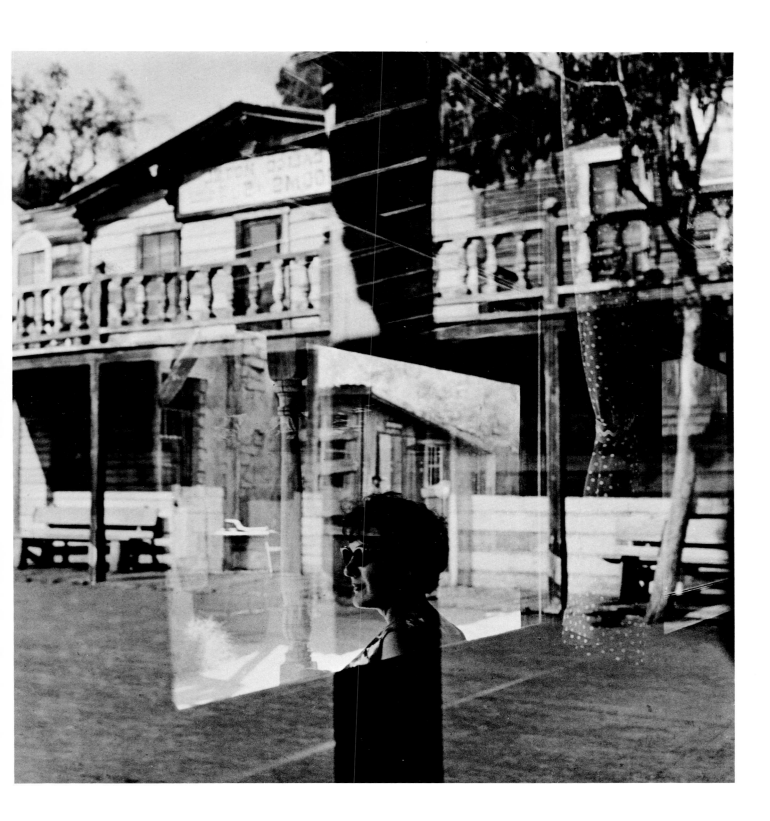

3

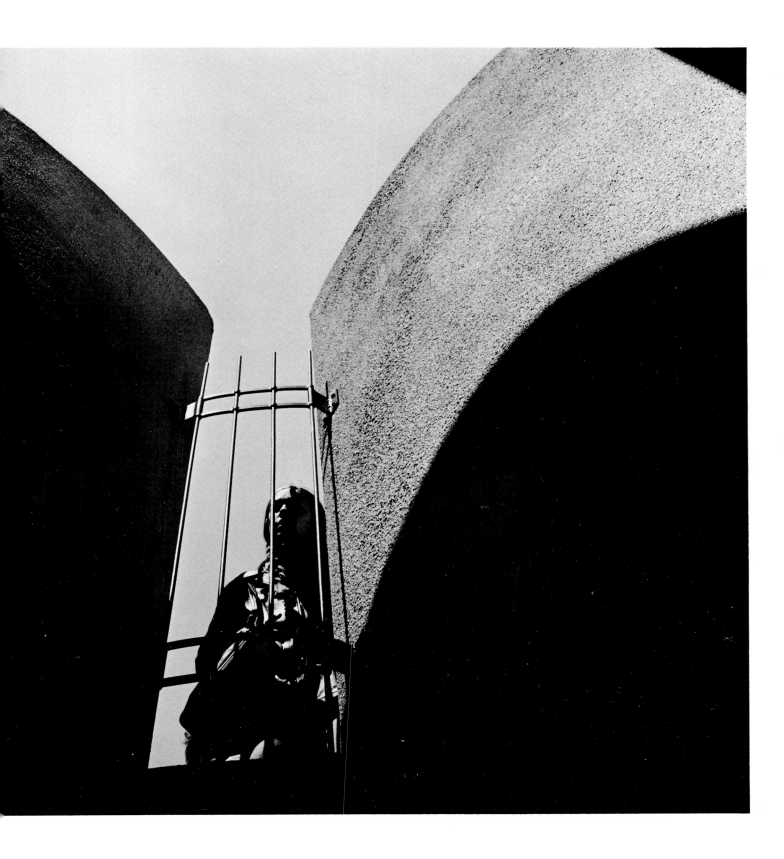

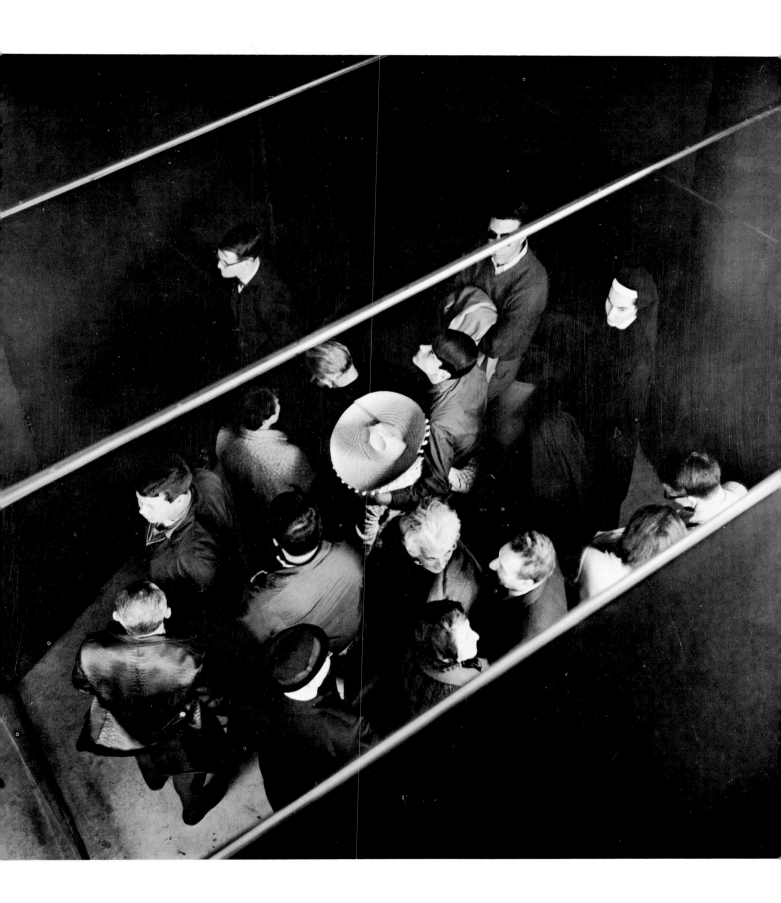

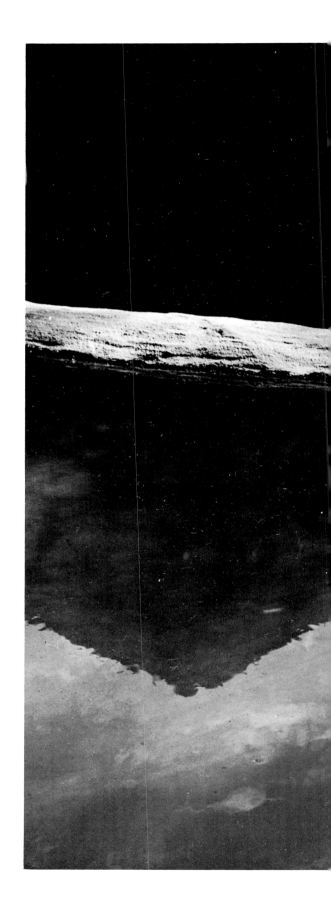

5

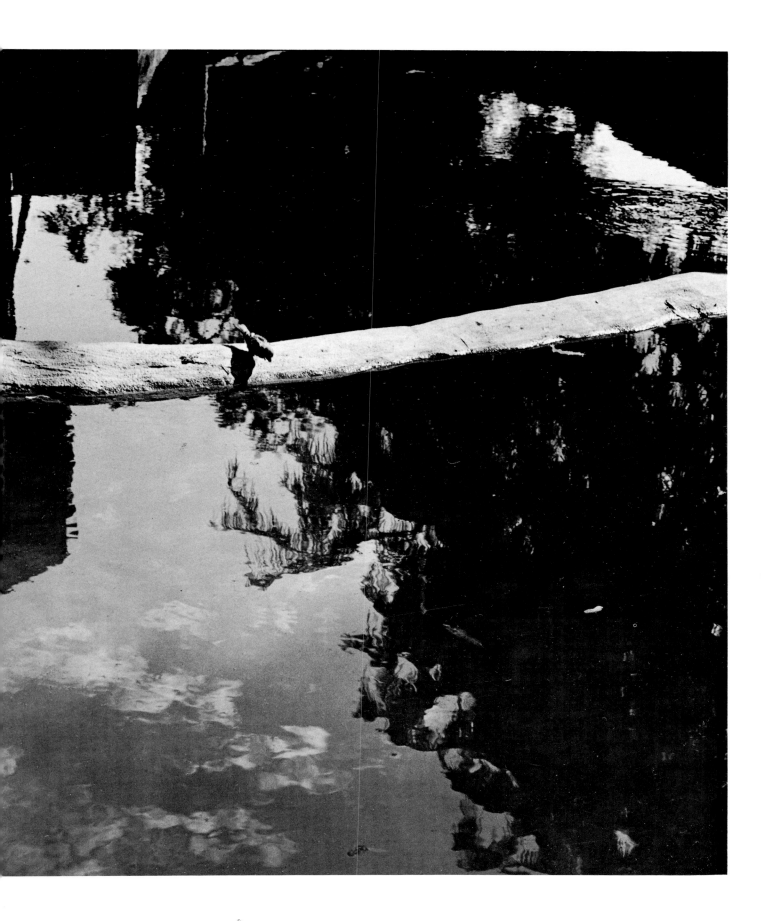

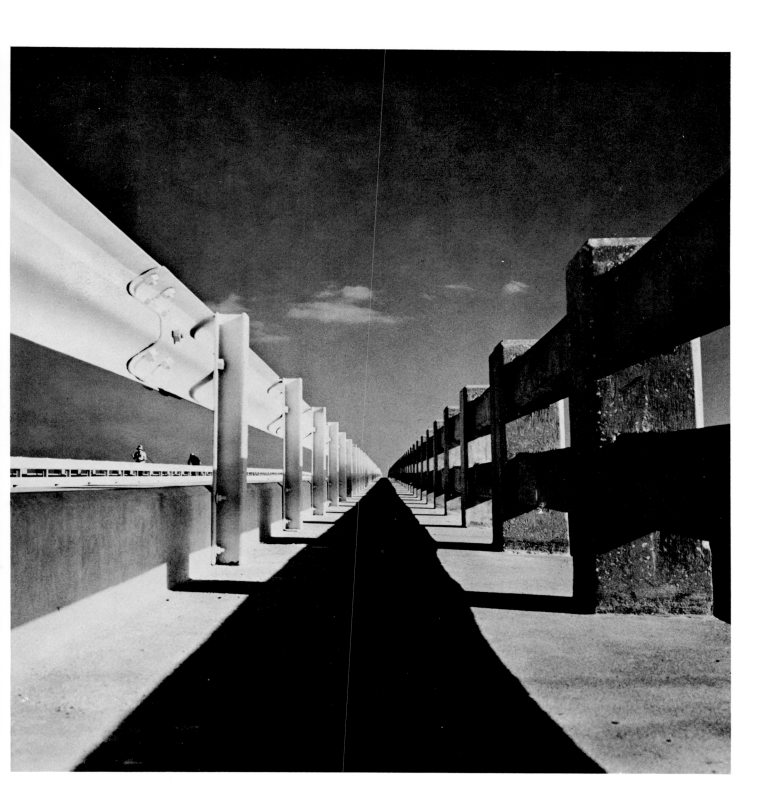

7

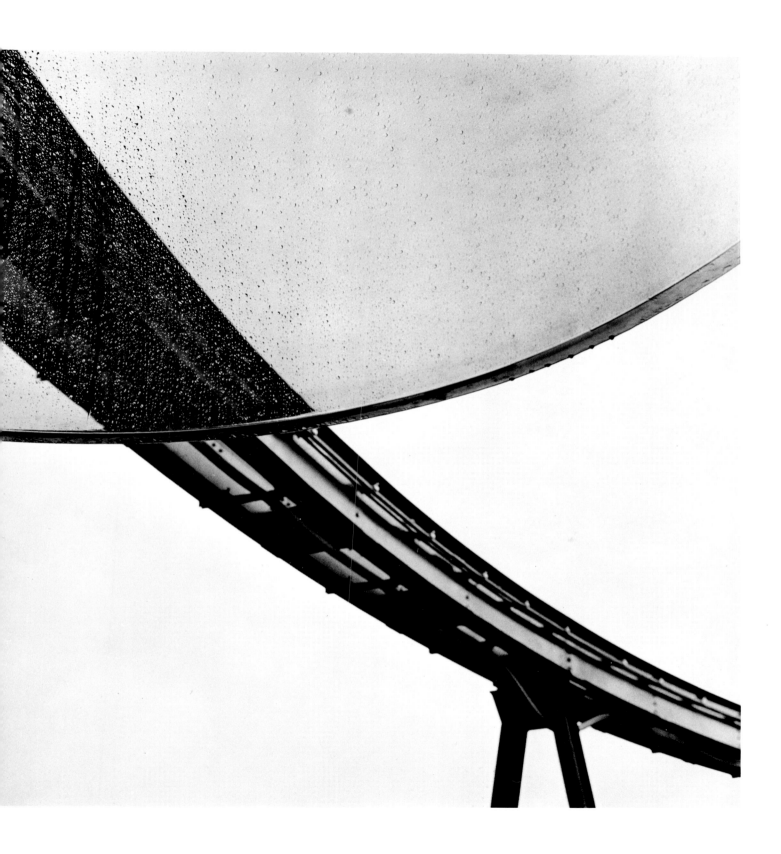

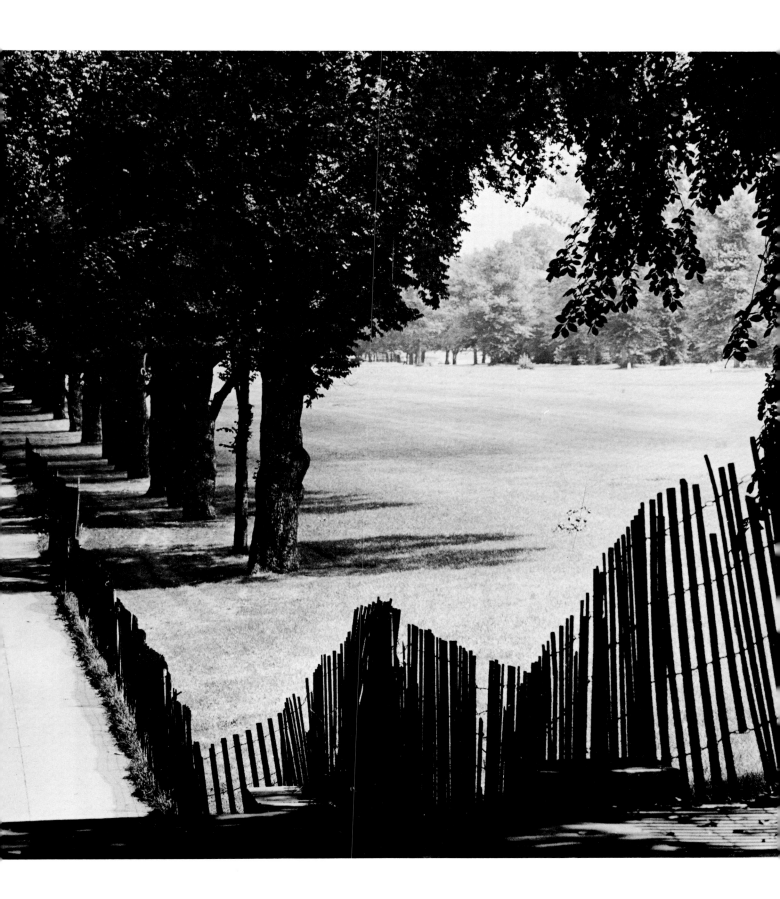

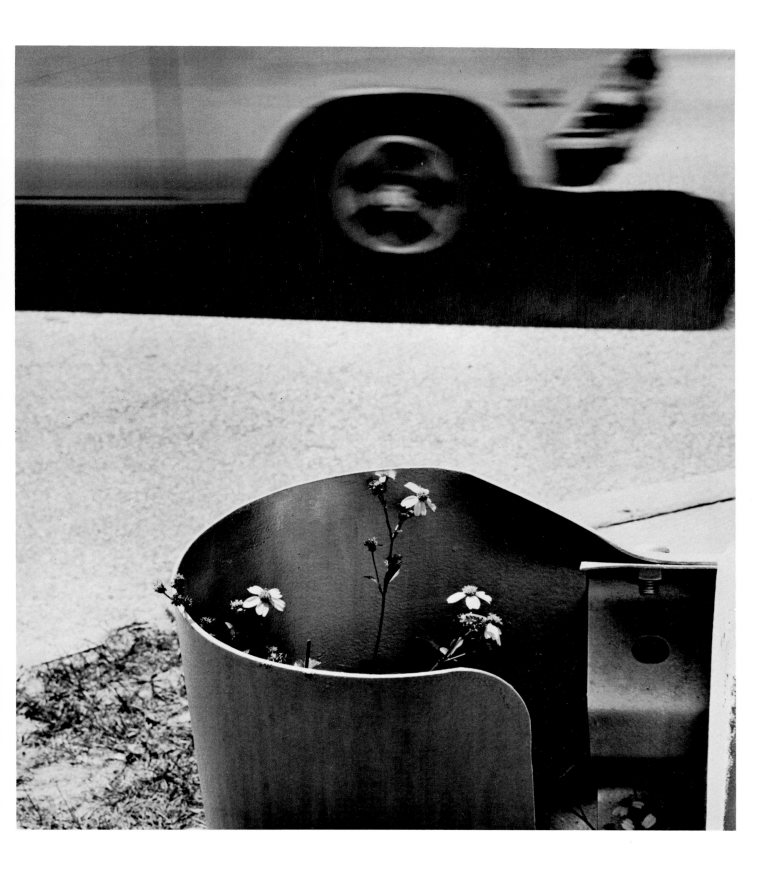

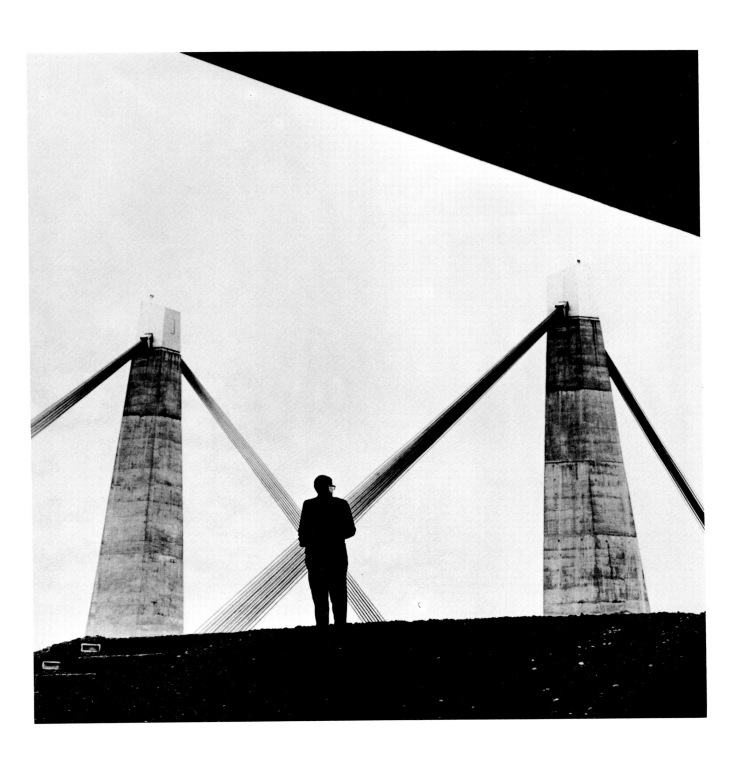

11

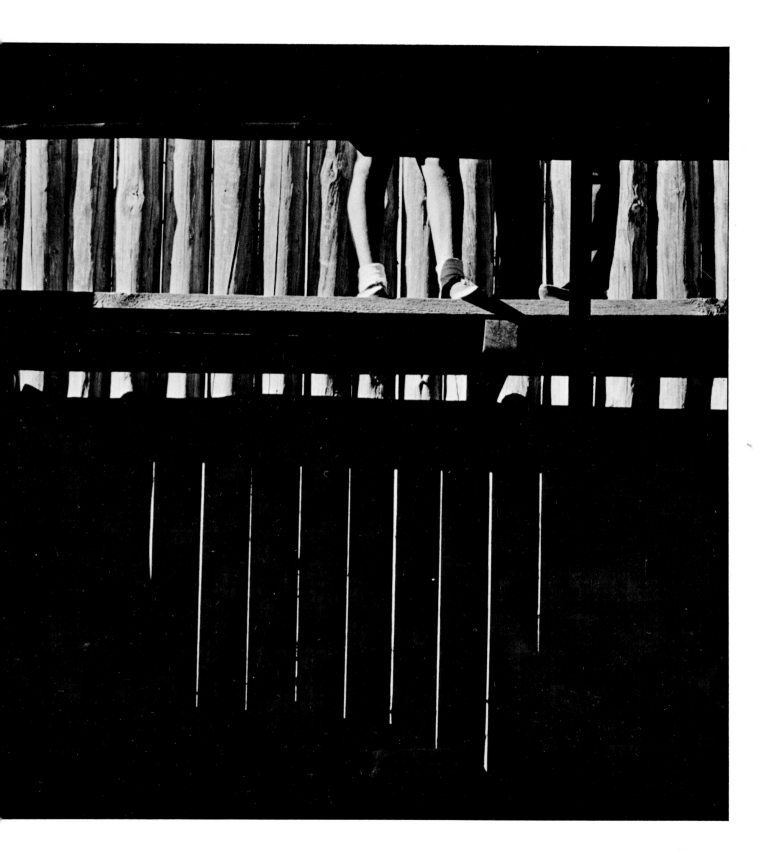

12

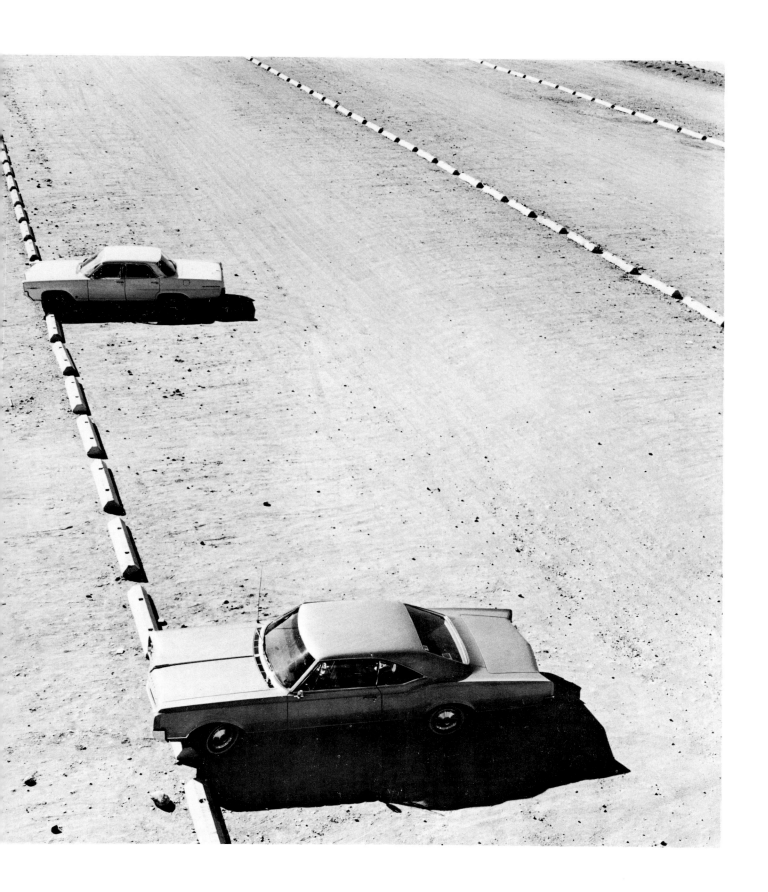

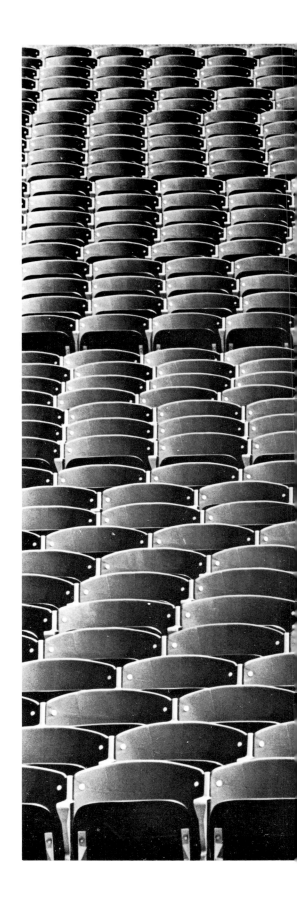

13

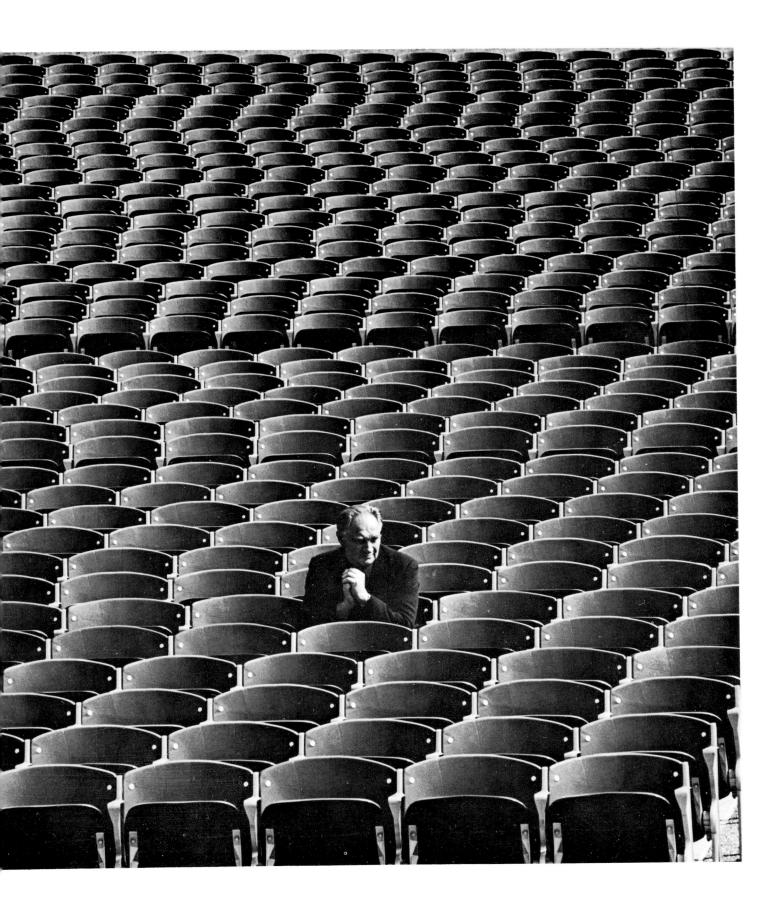

14

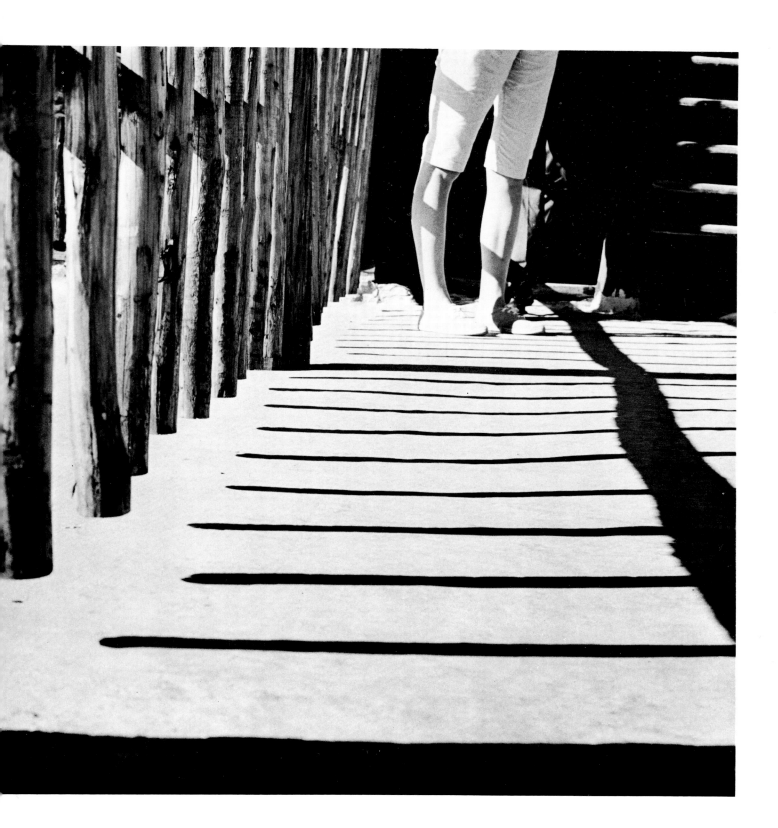

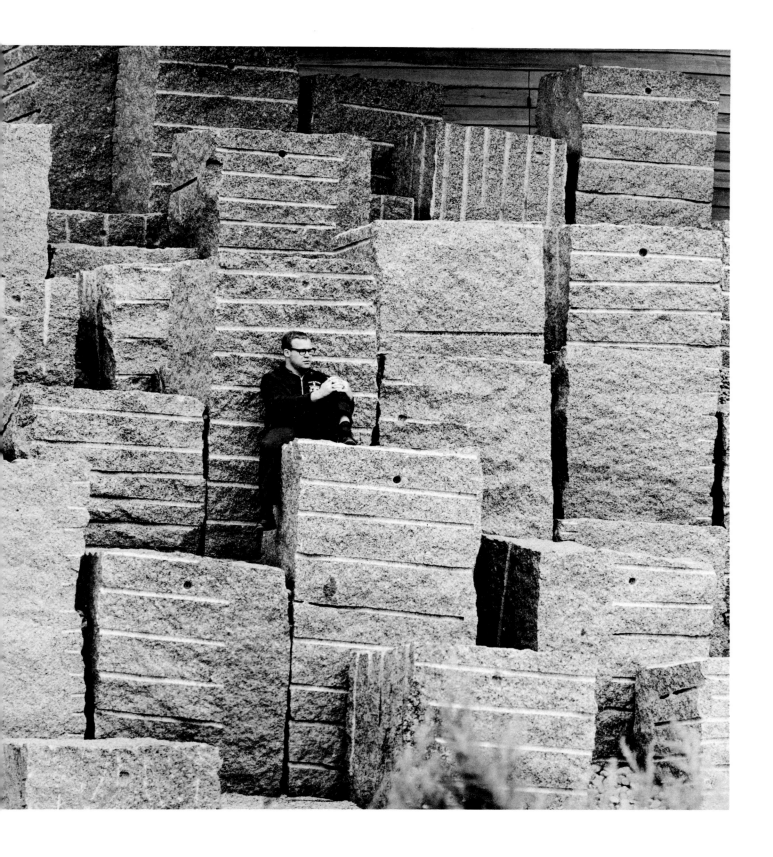

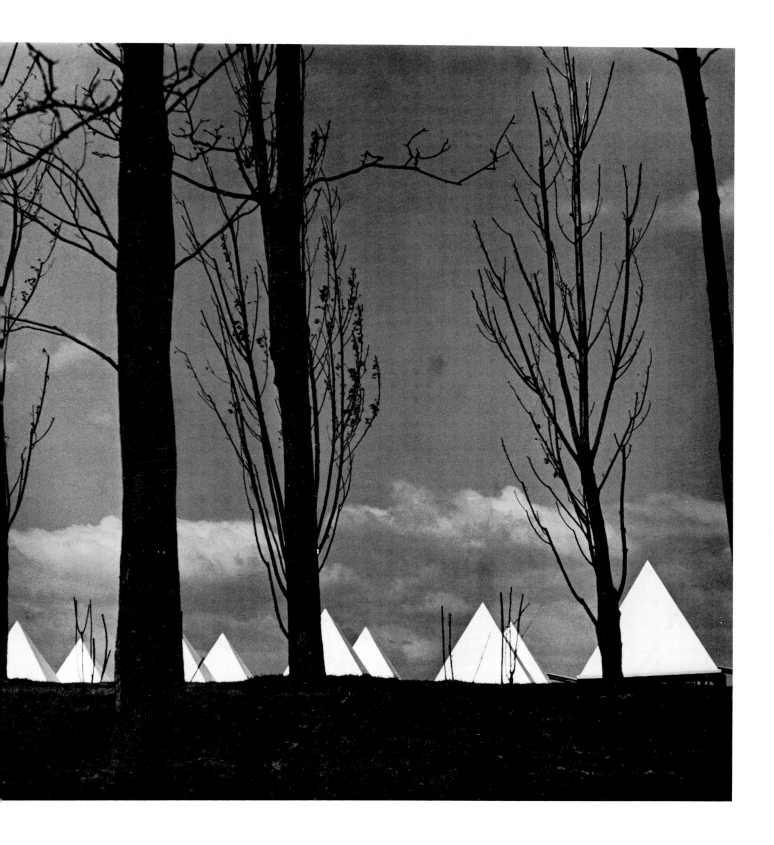

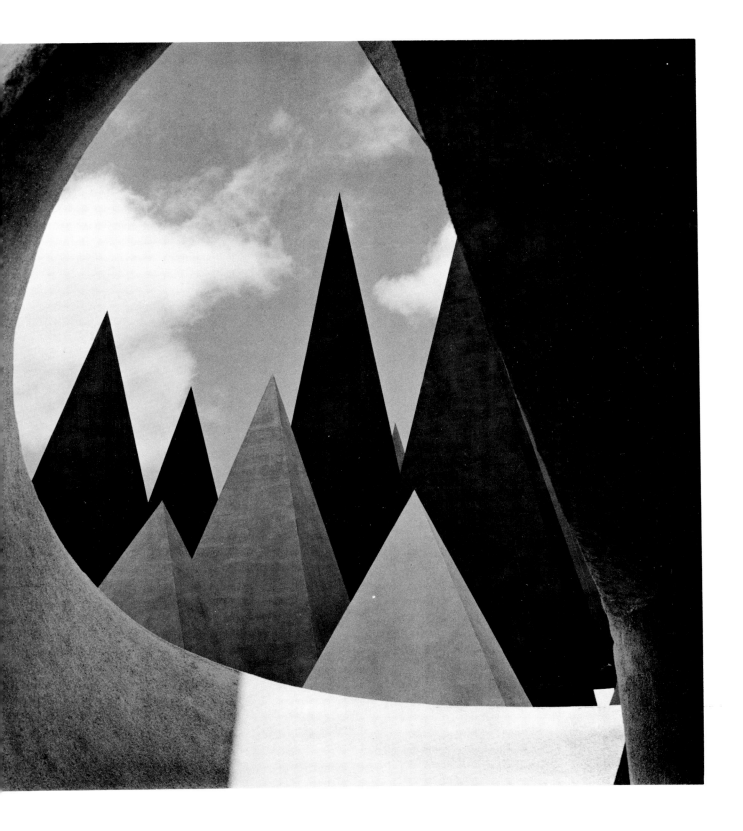

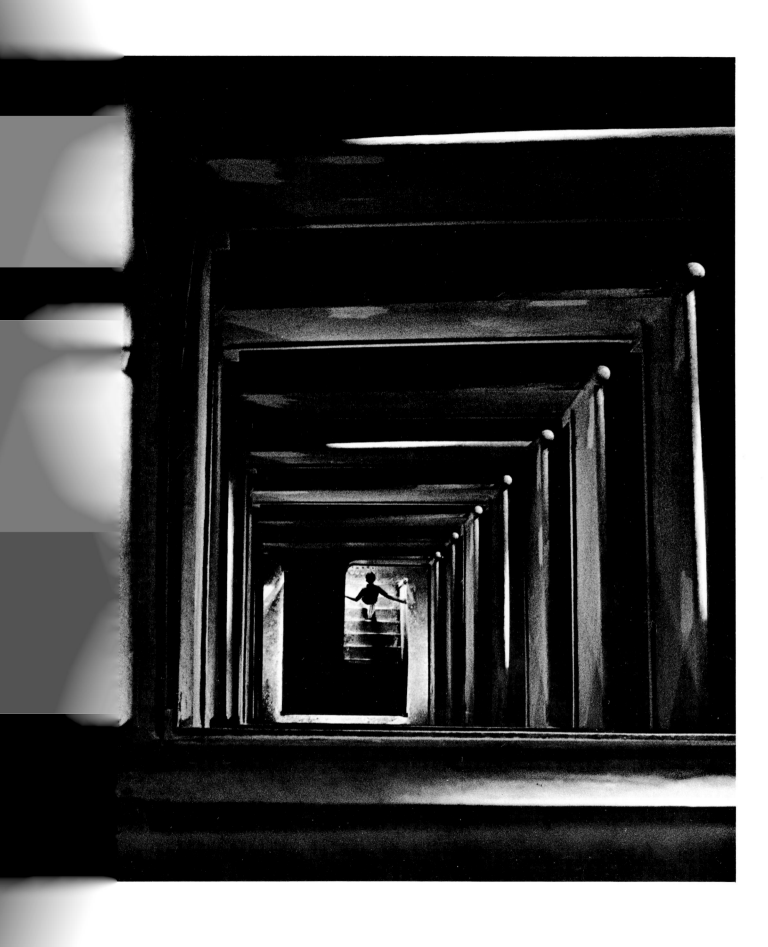

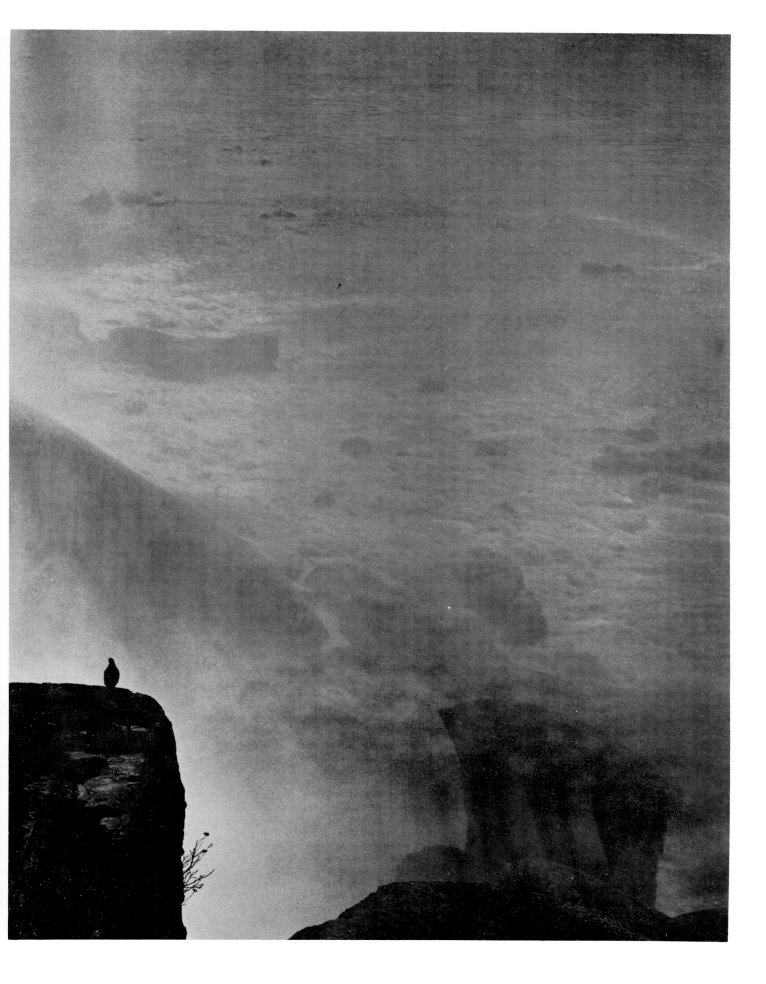

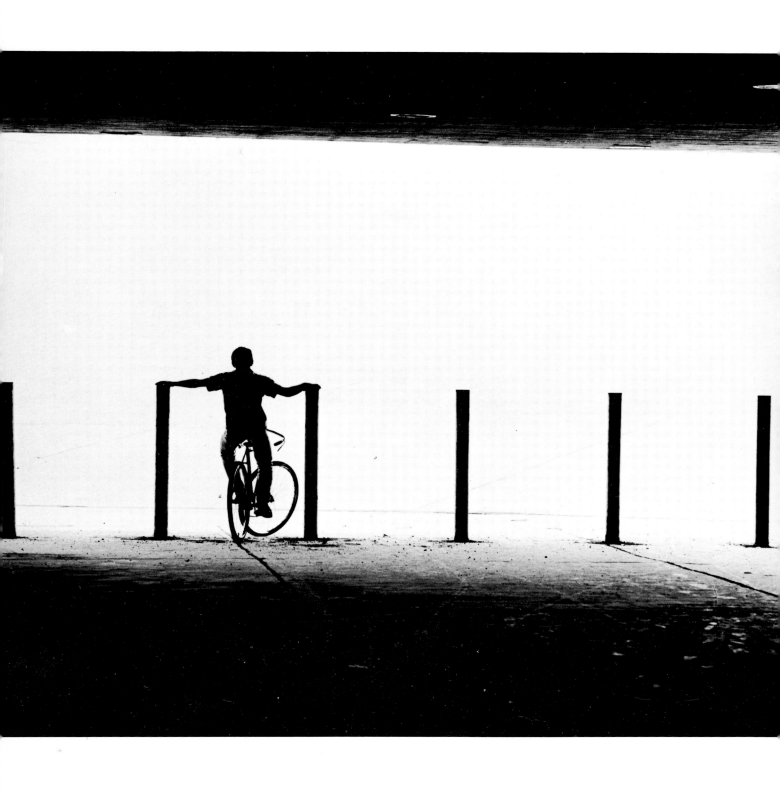

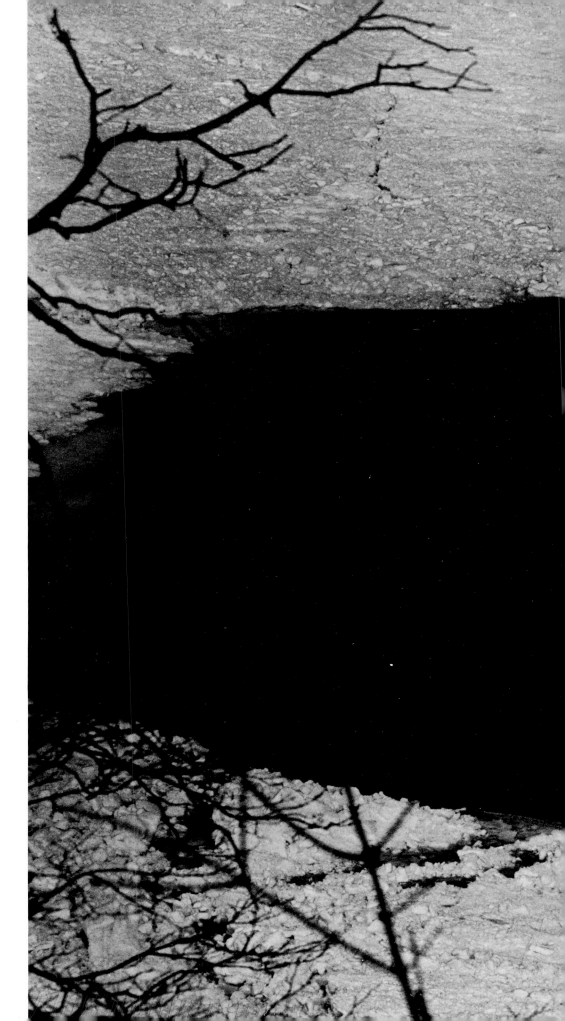

21

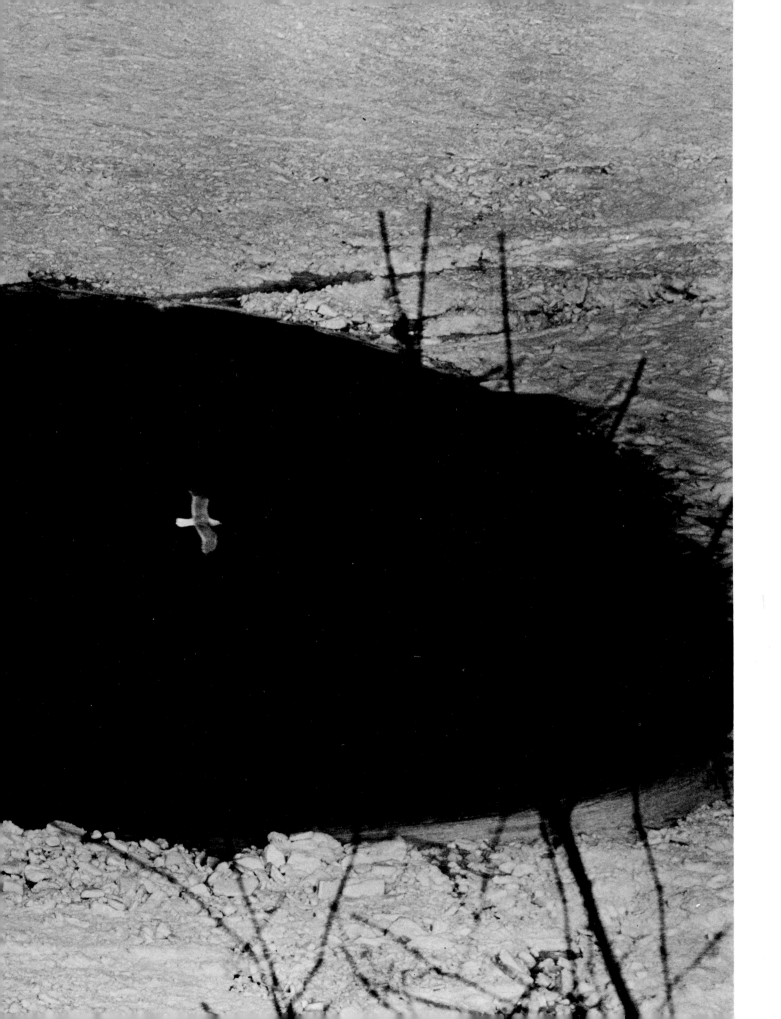

22

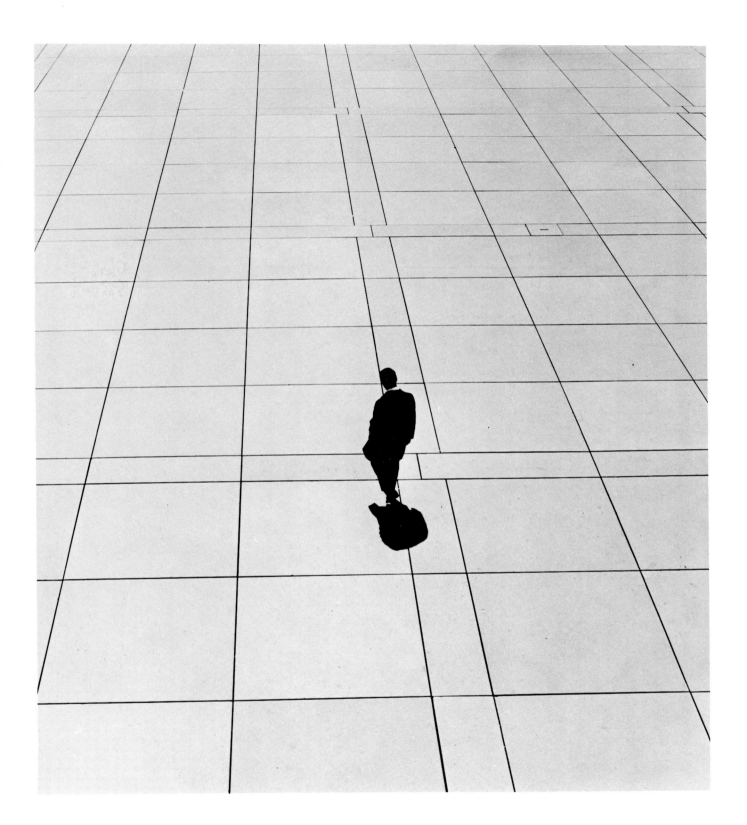

23

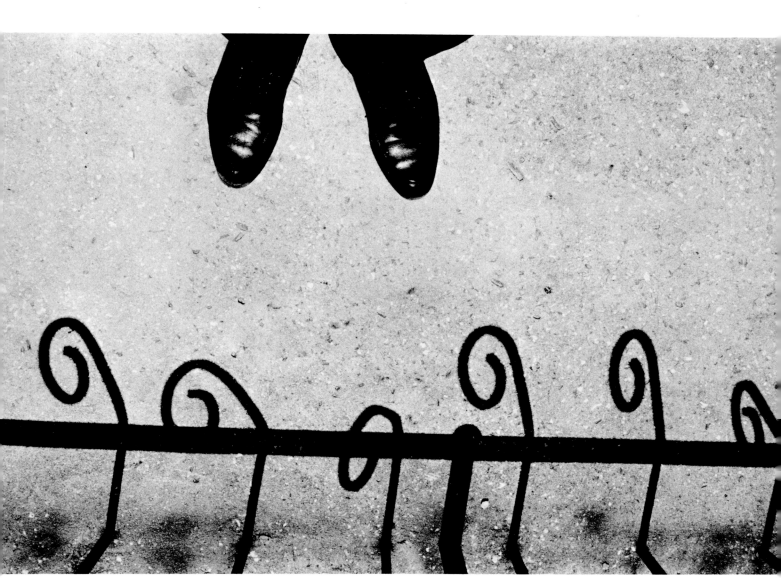

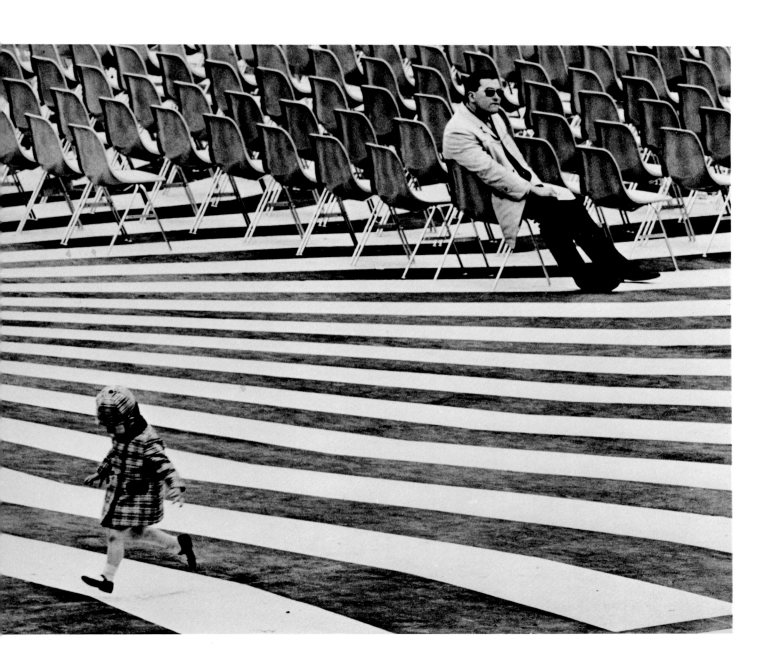

25

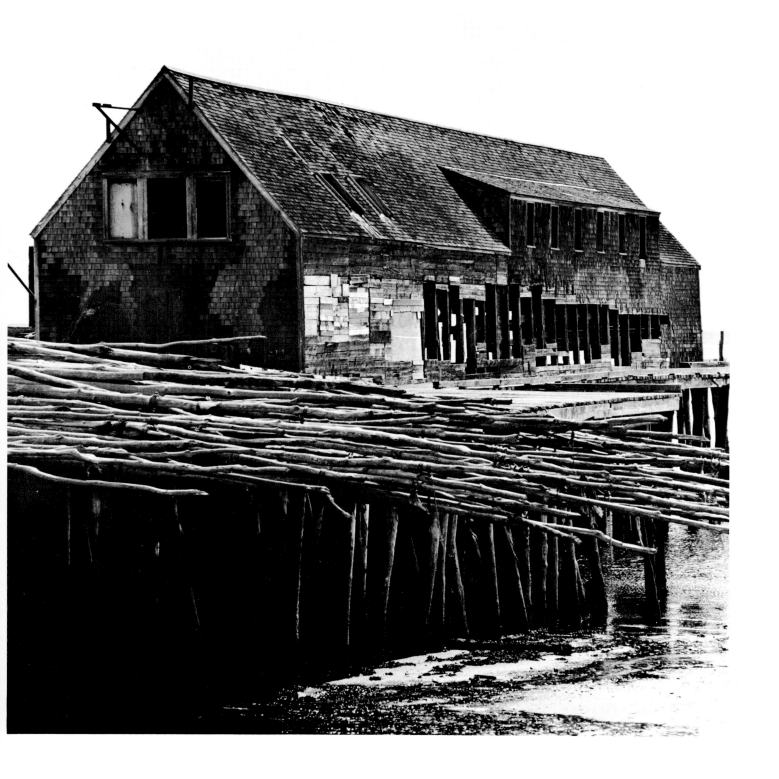

26

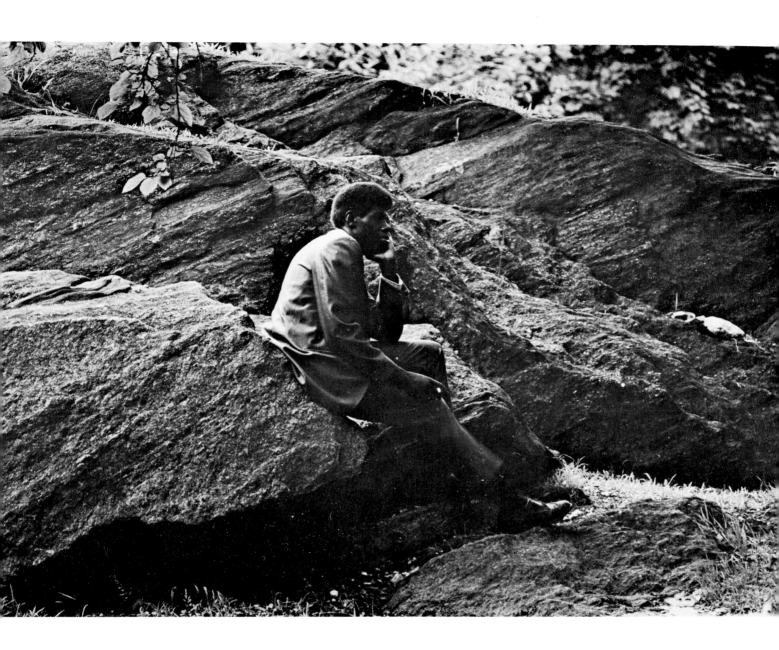

27

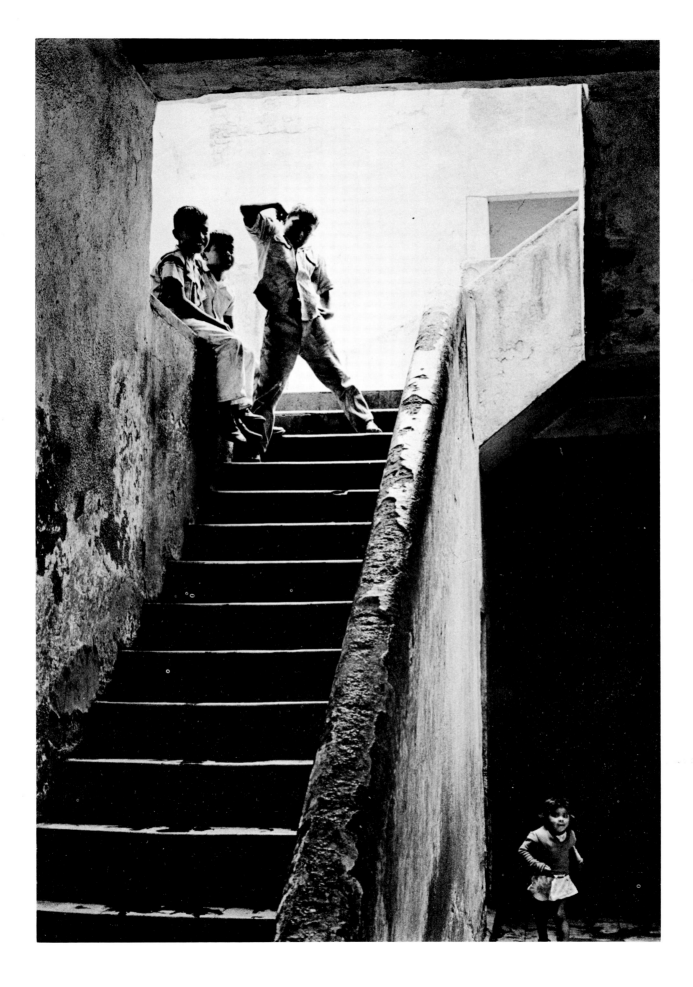

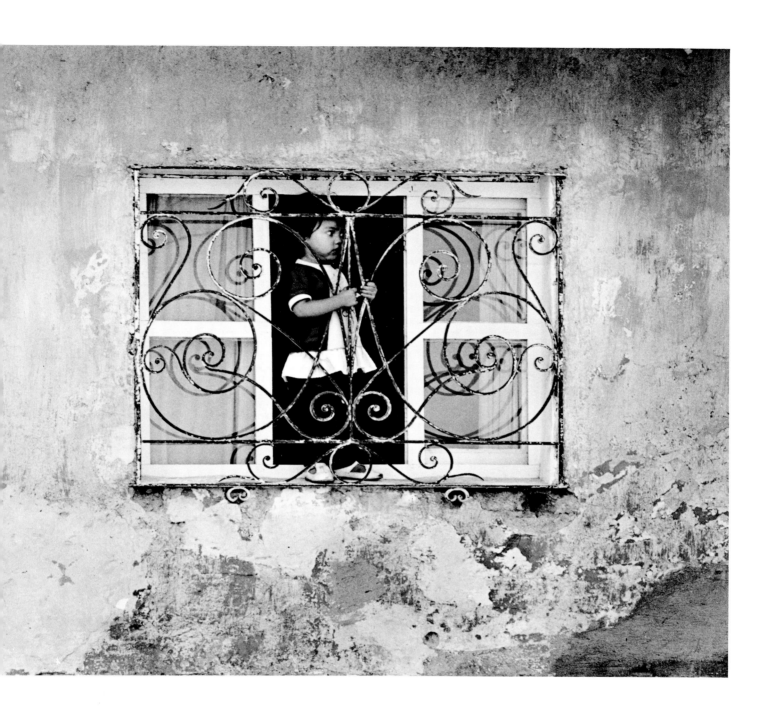

29

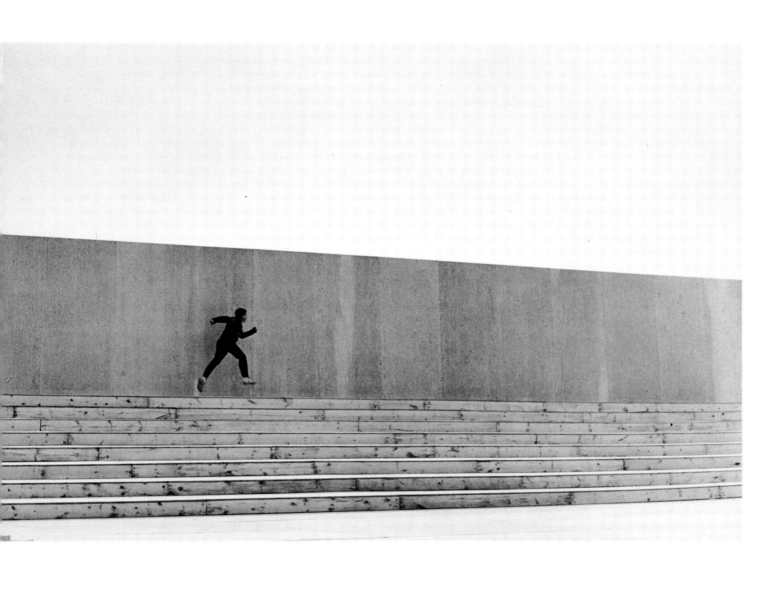

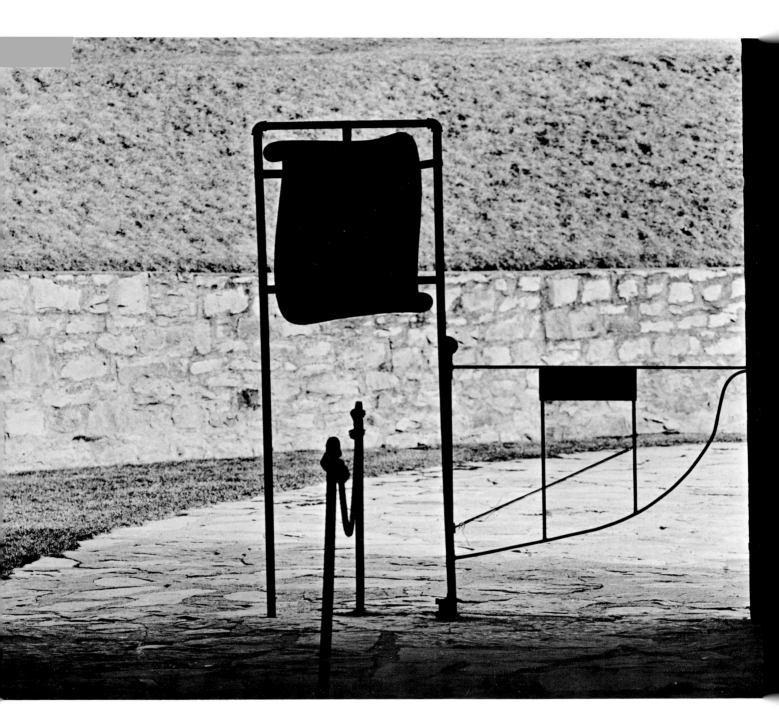

31

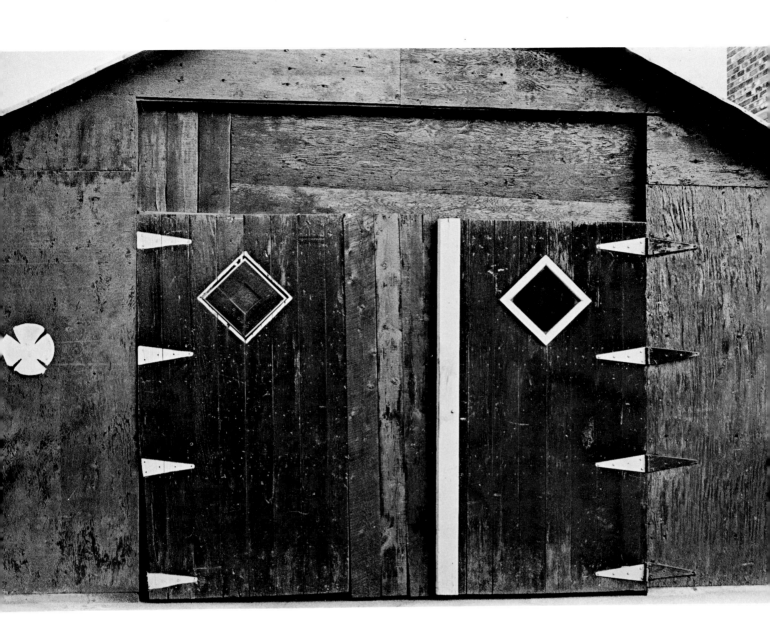

32

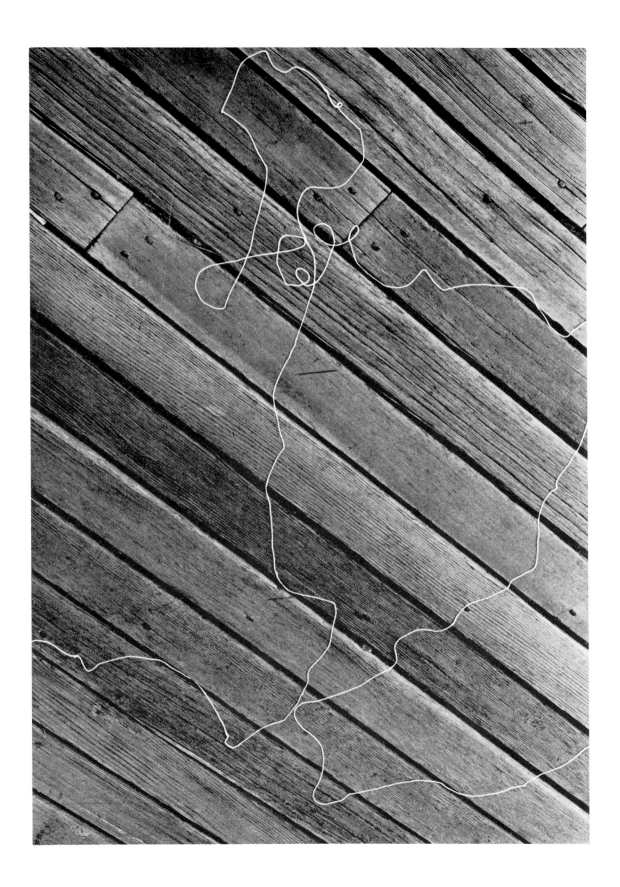

33

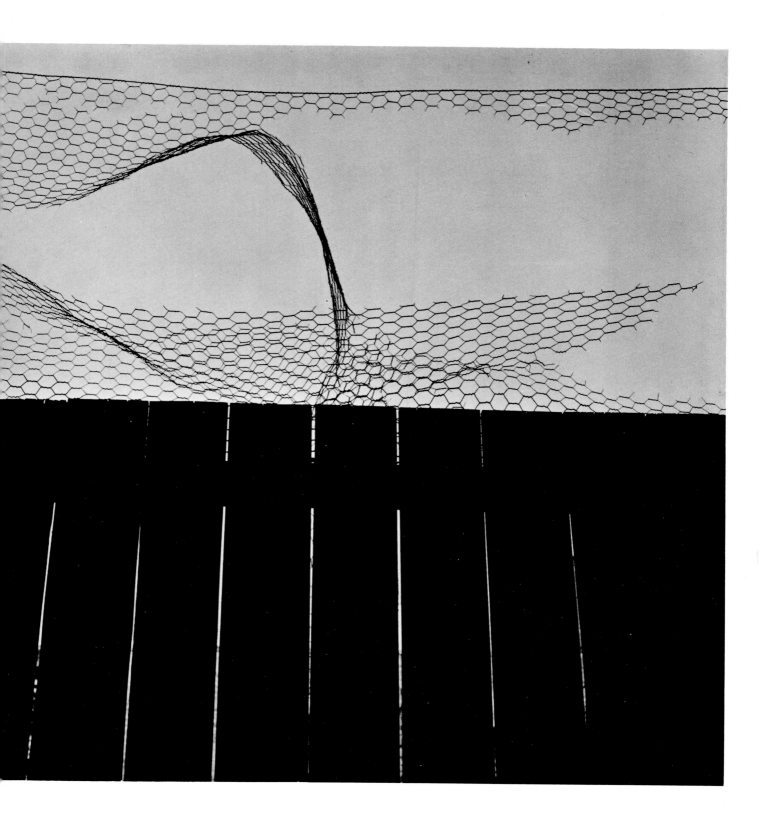

34

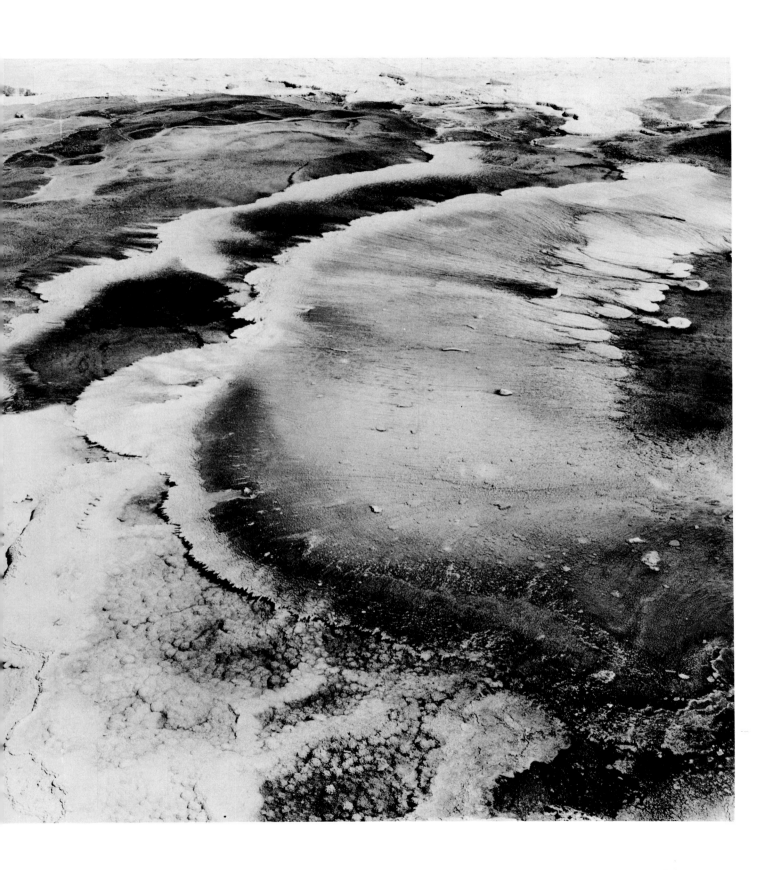

35

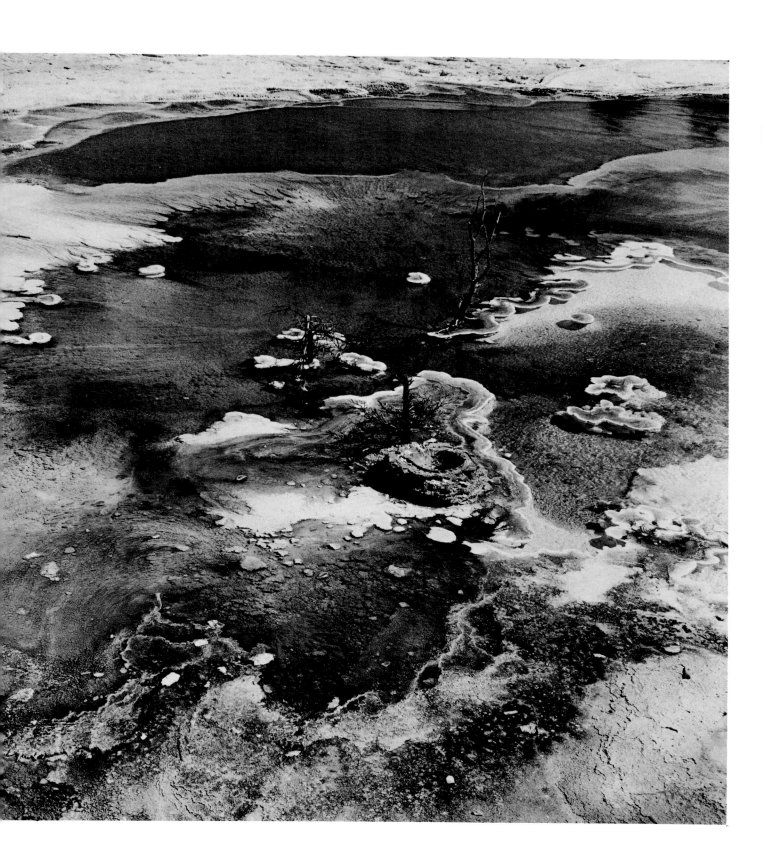

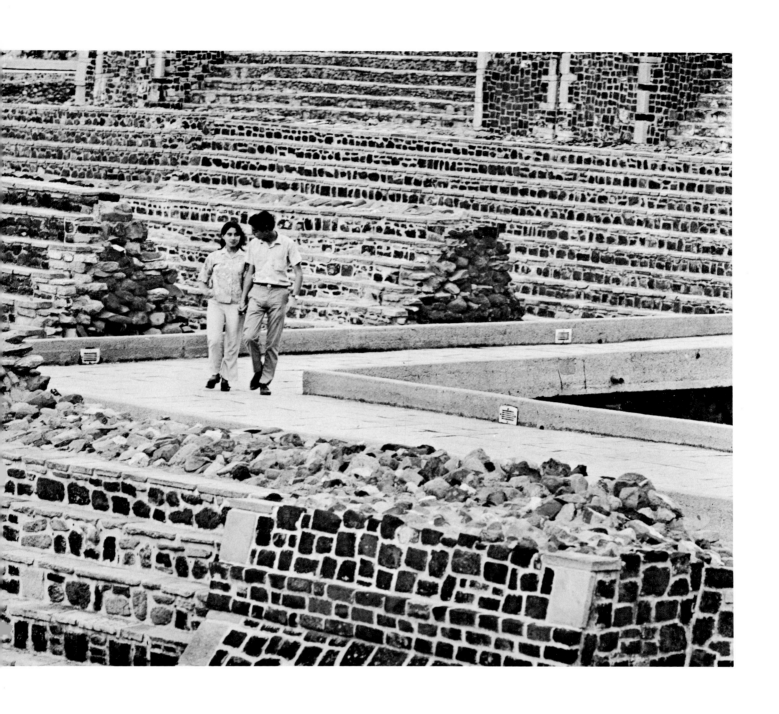

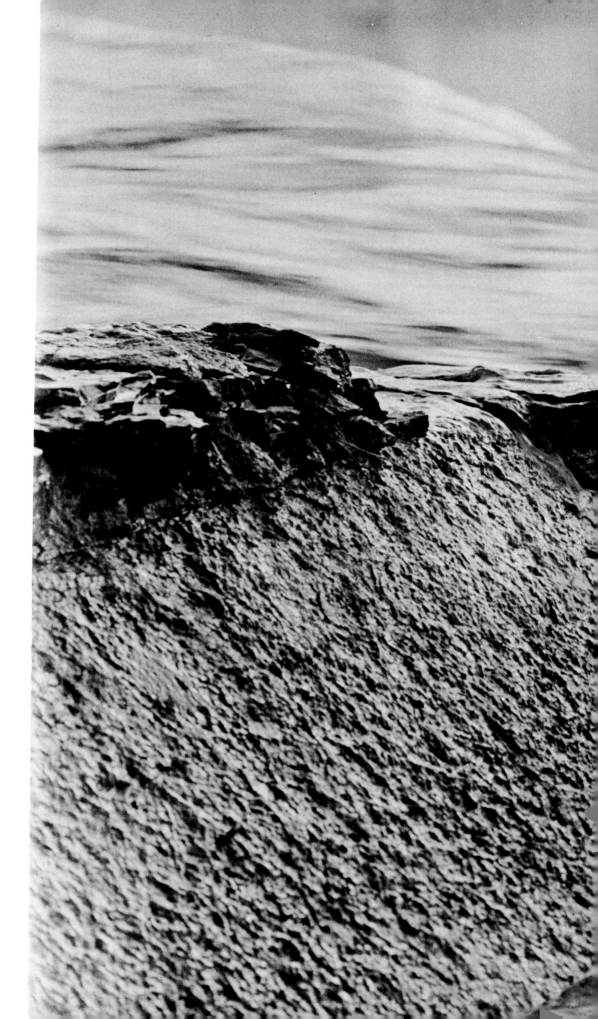

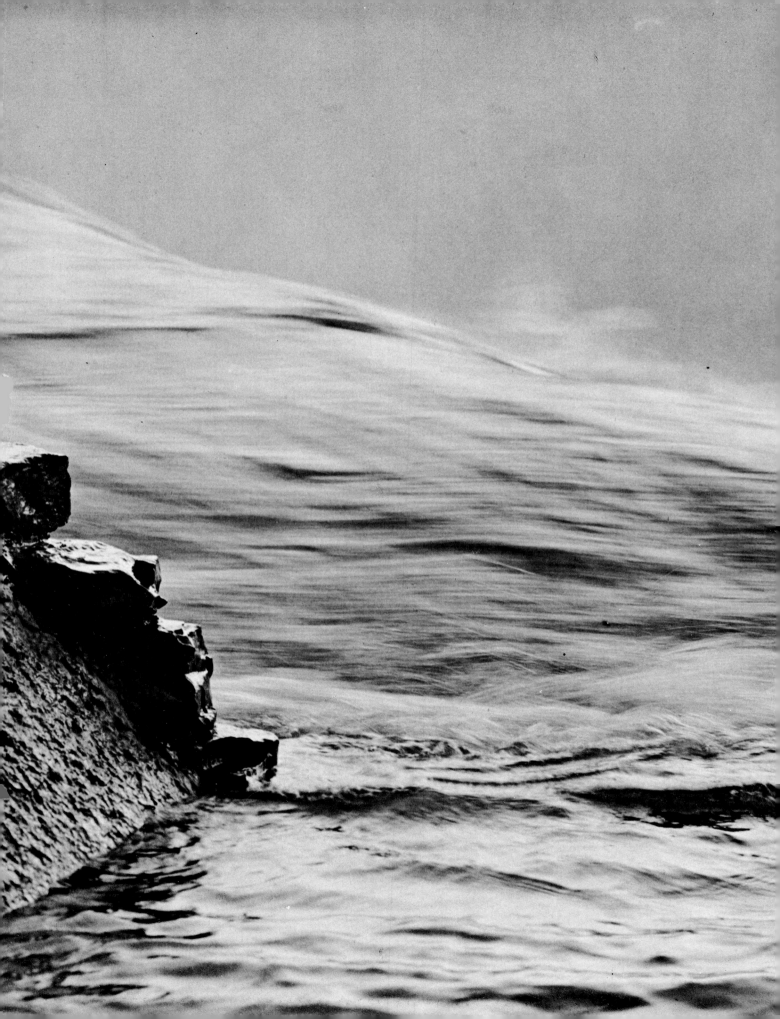

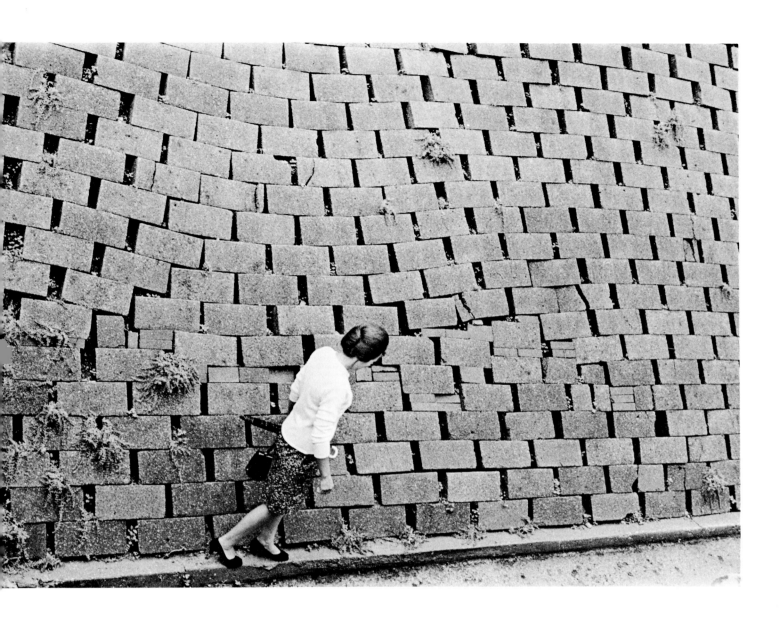

39

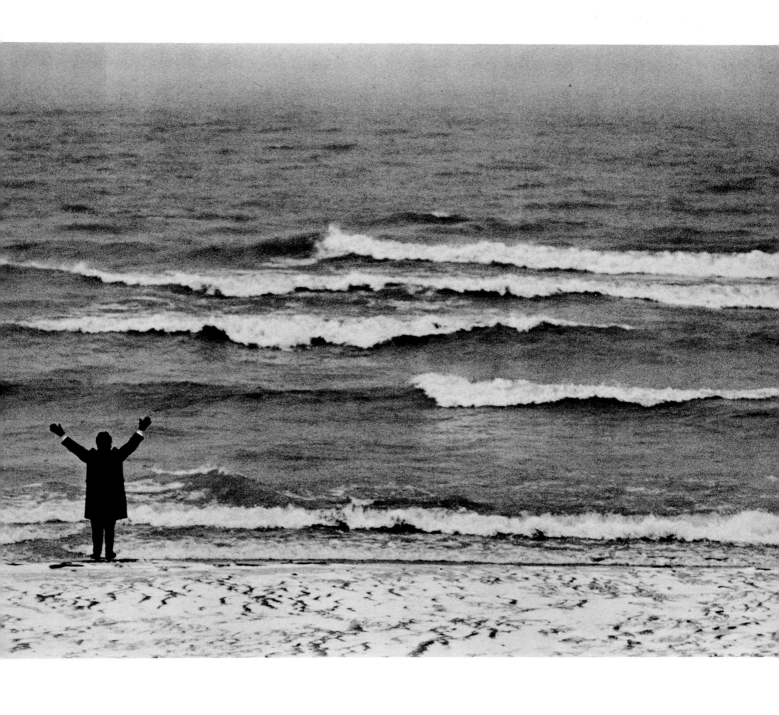

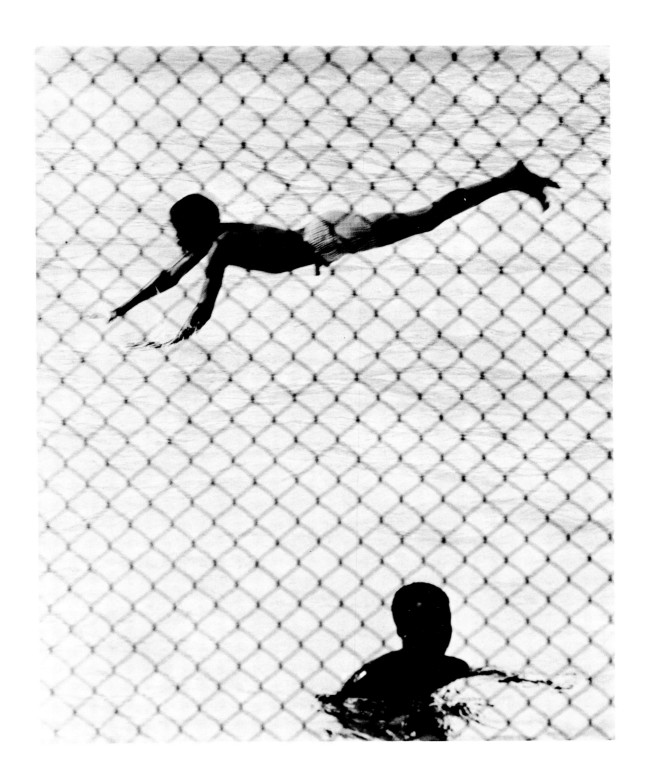

41

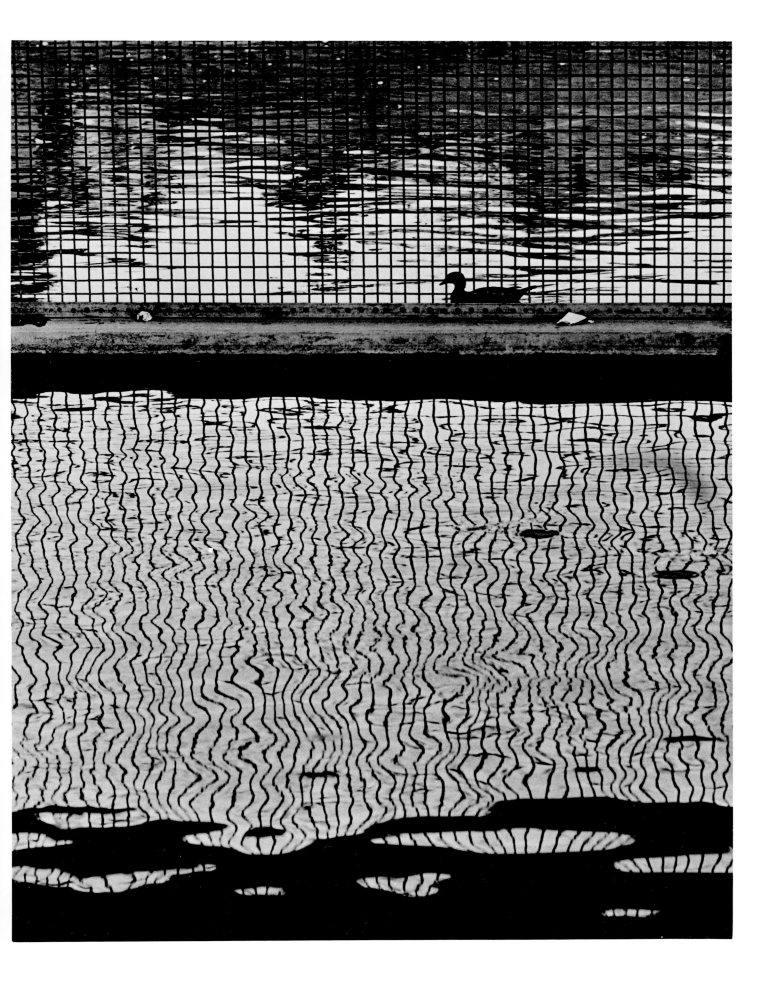

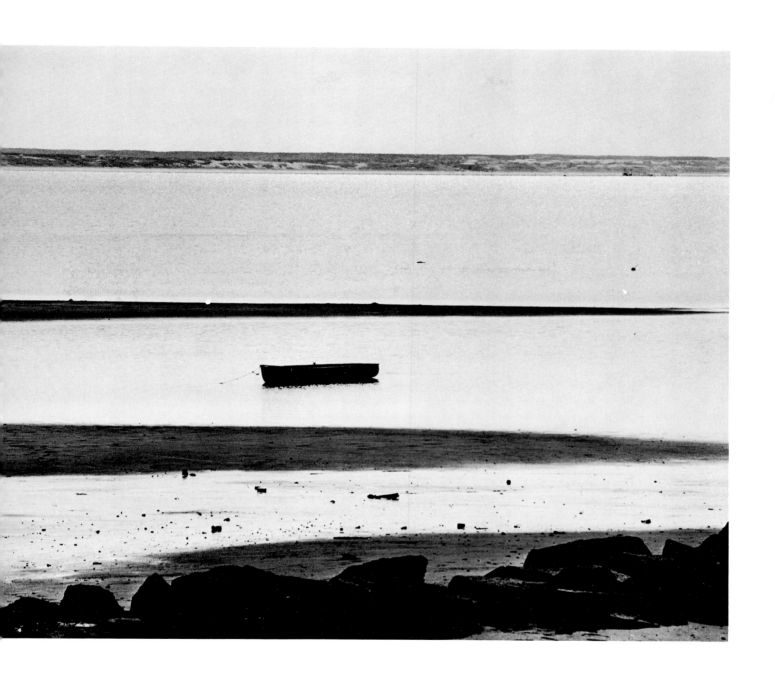

43

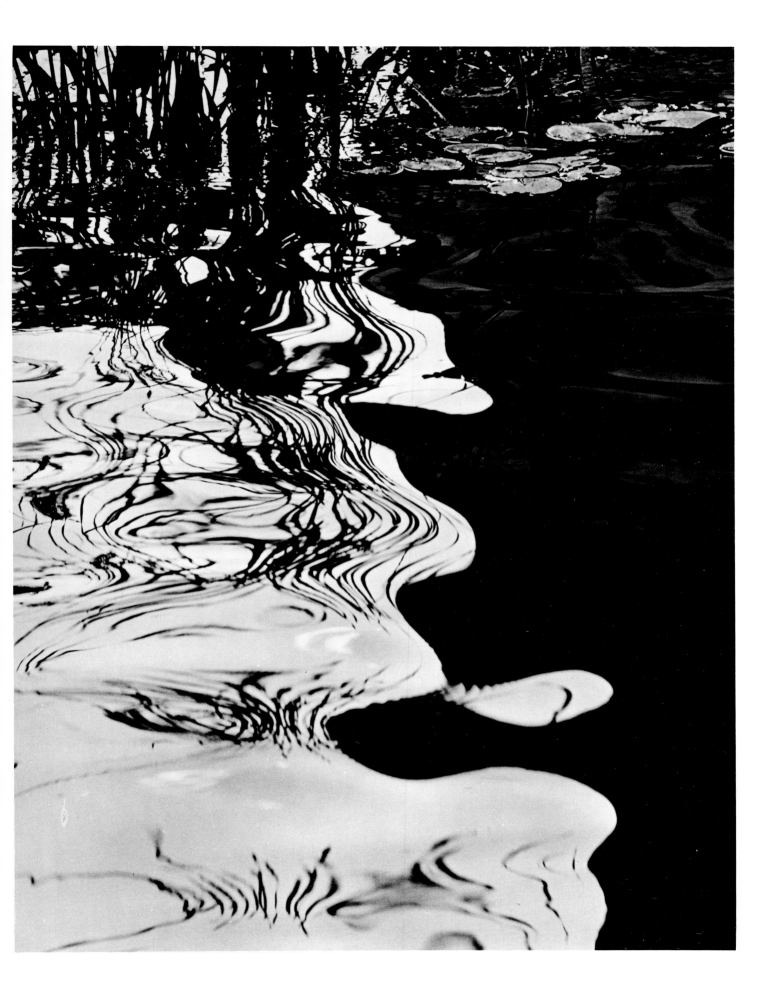

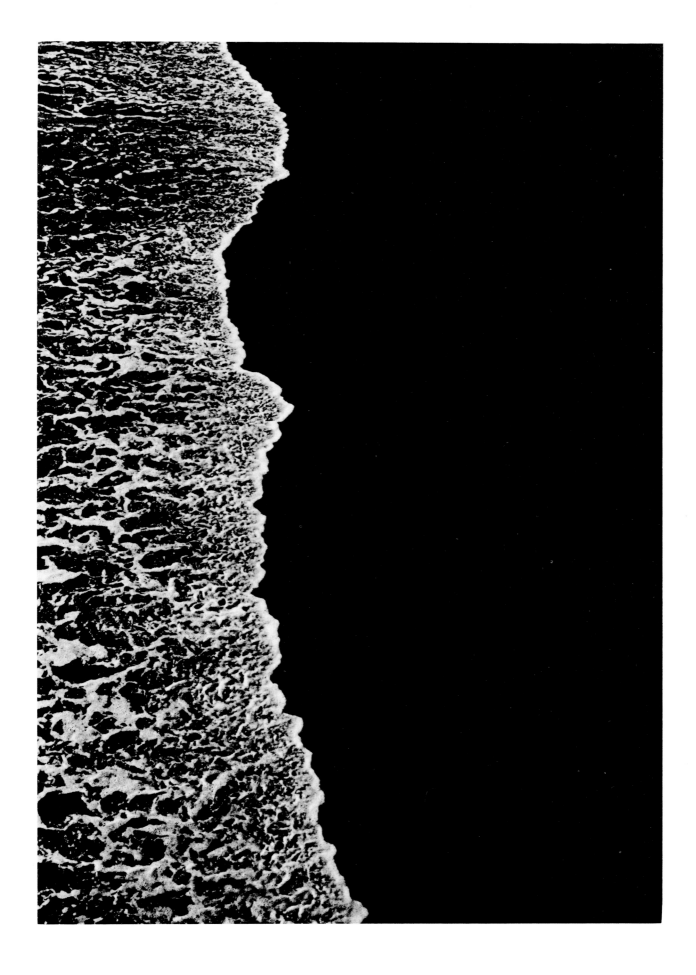

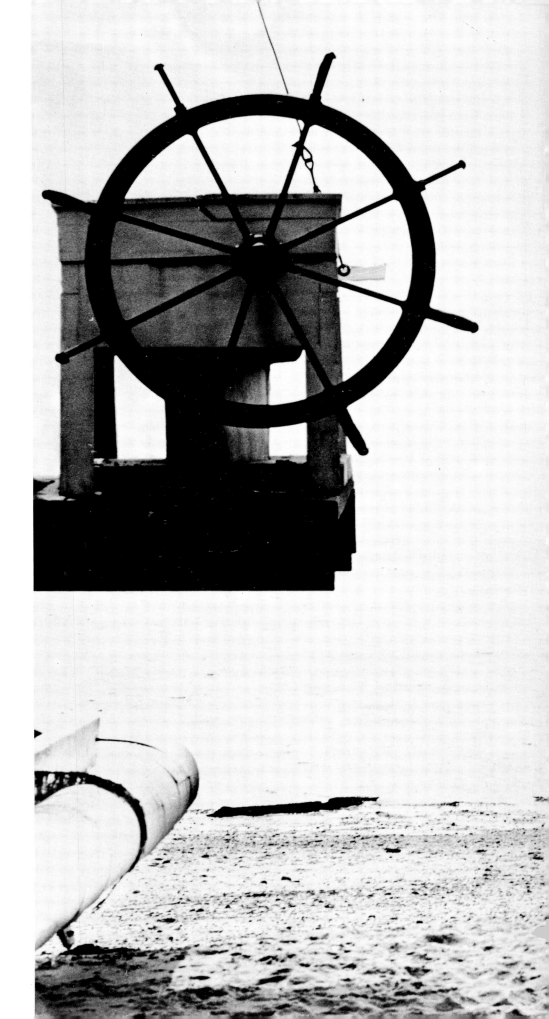

45

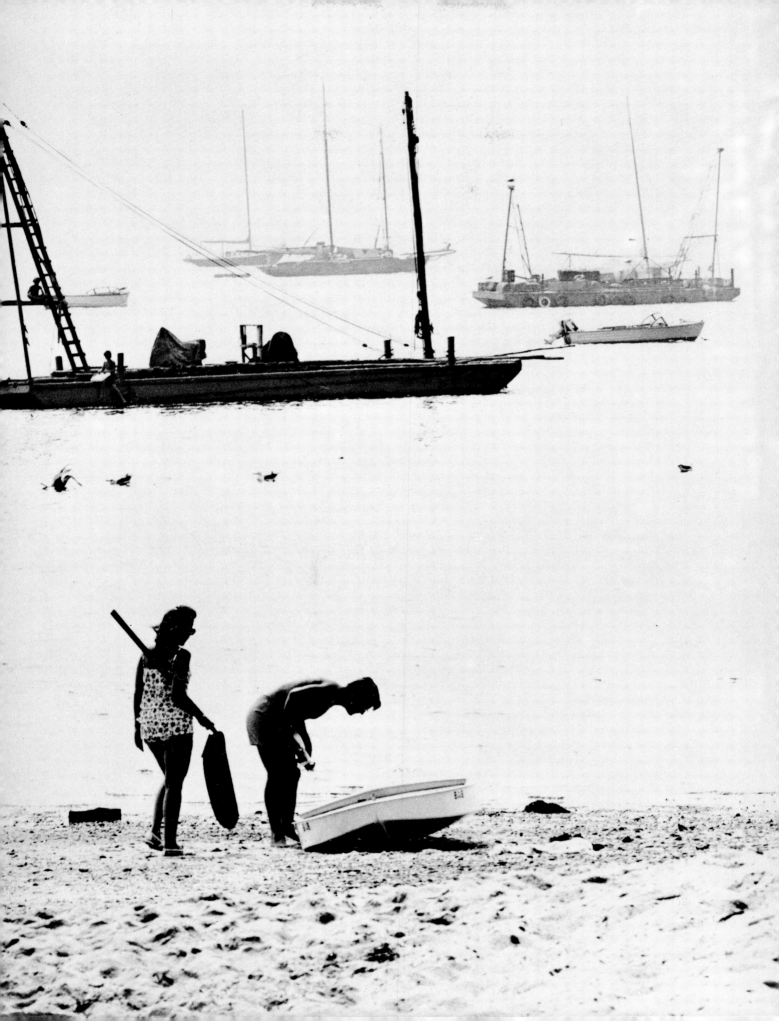

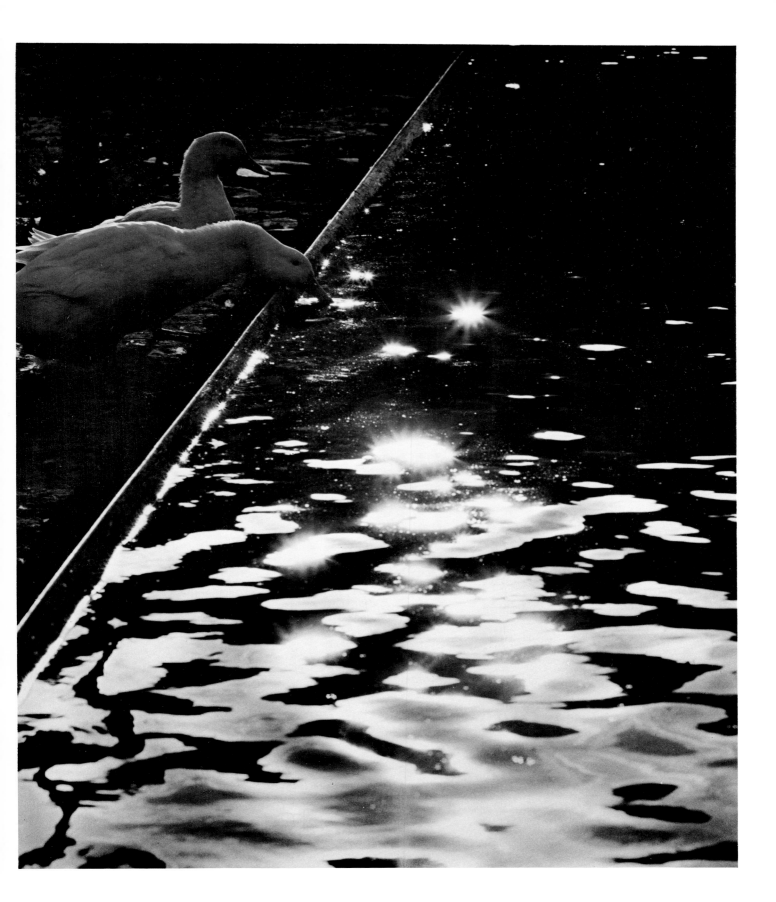

47

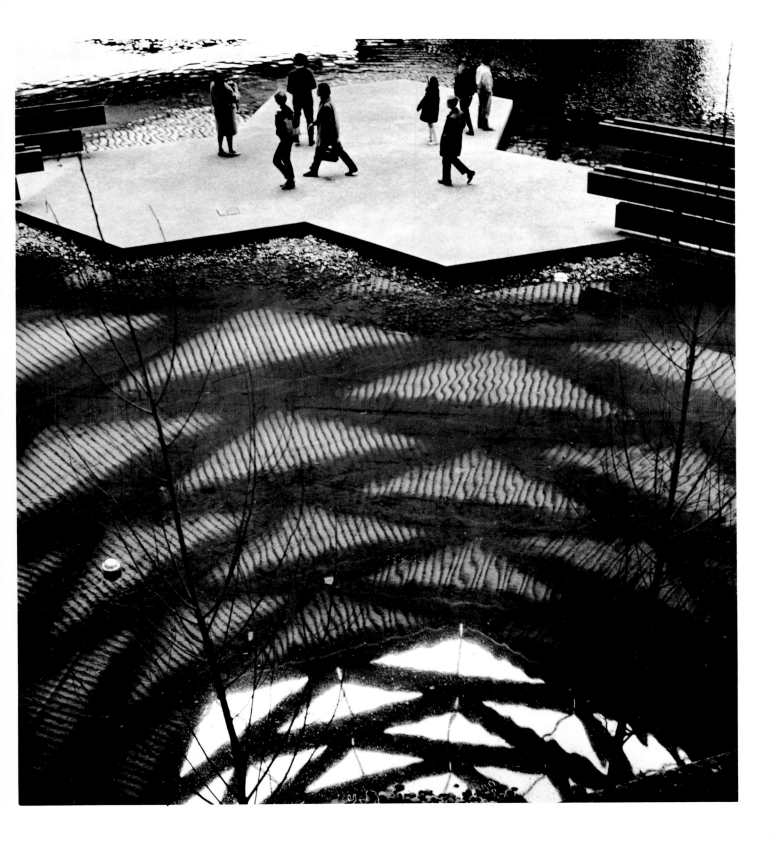

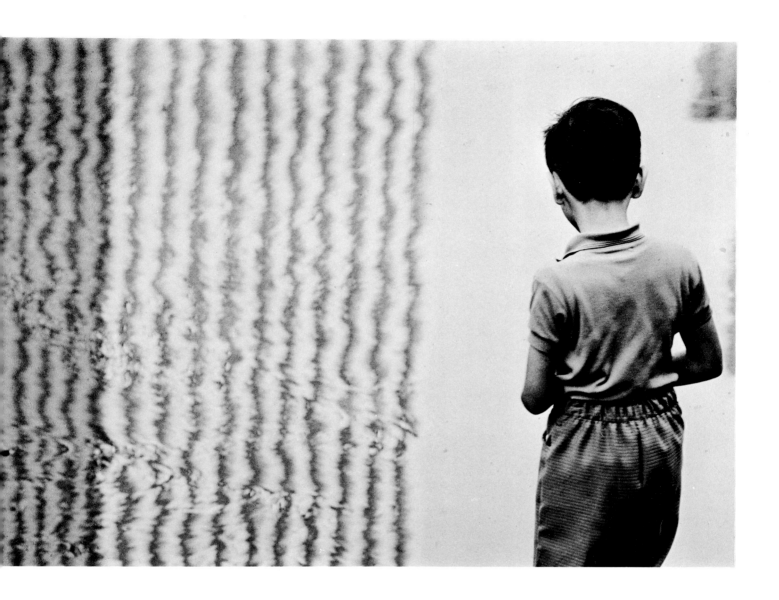

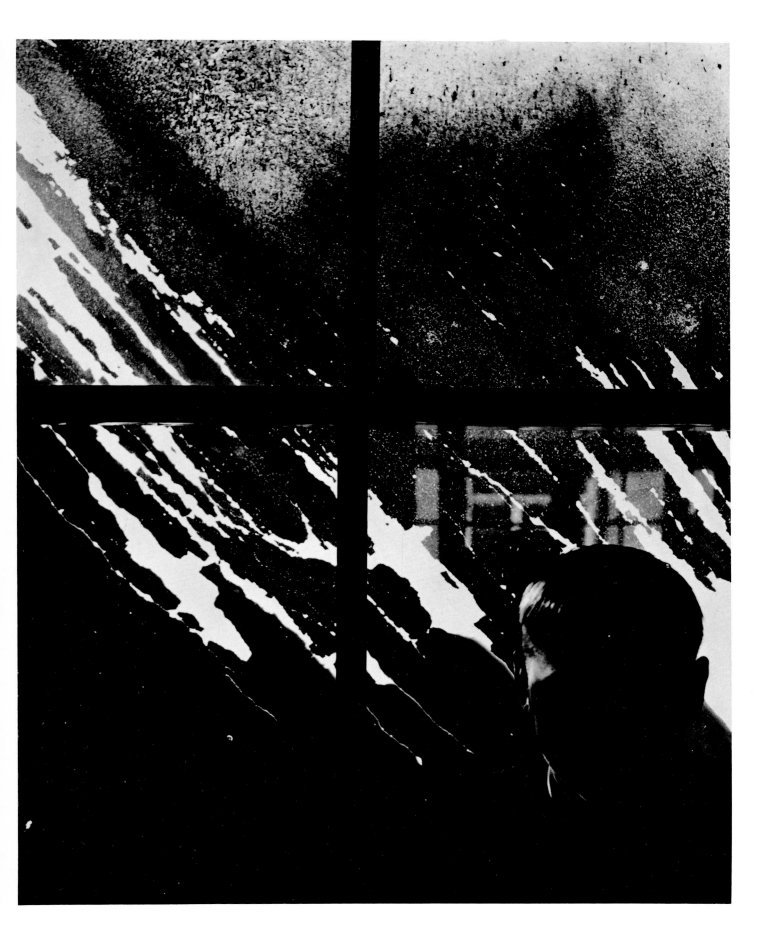

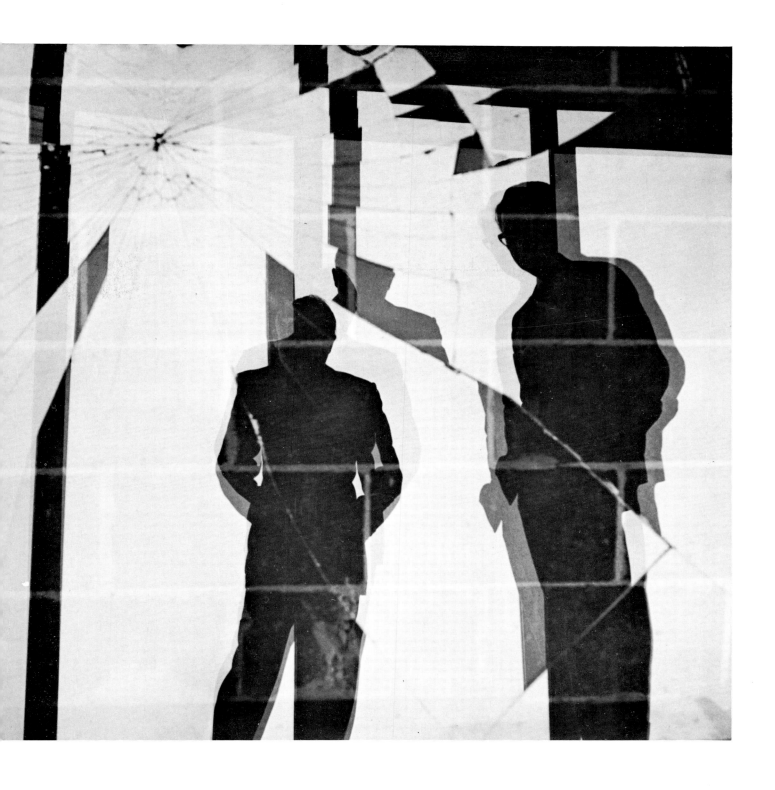

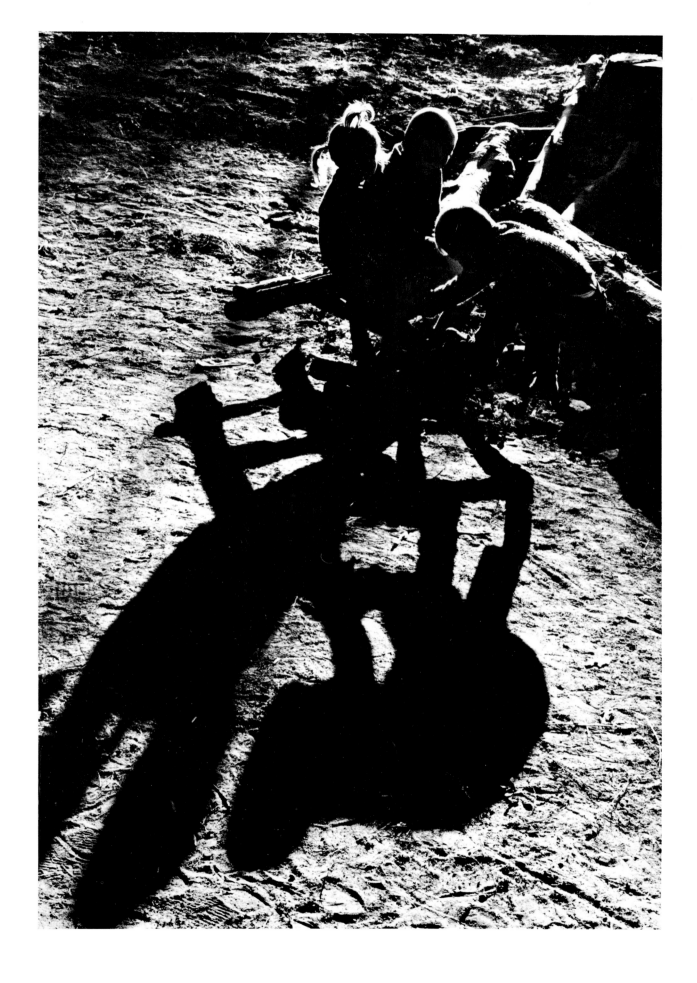

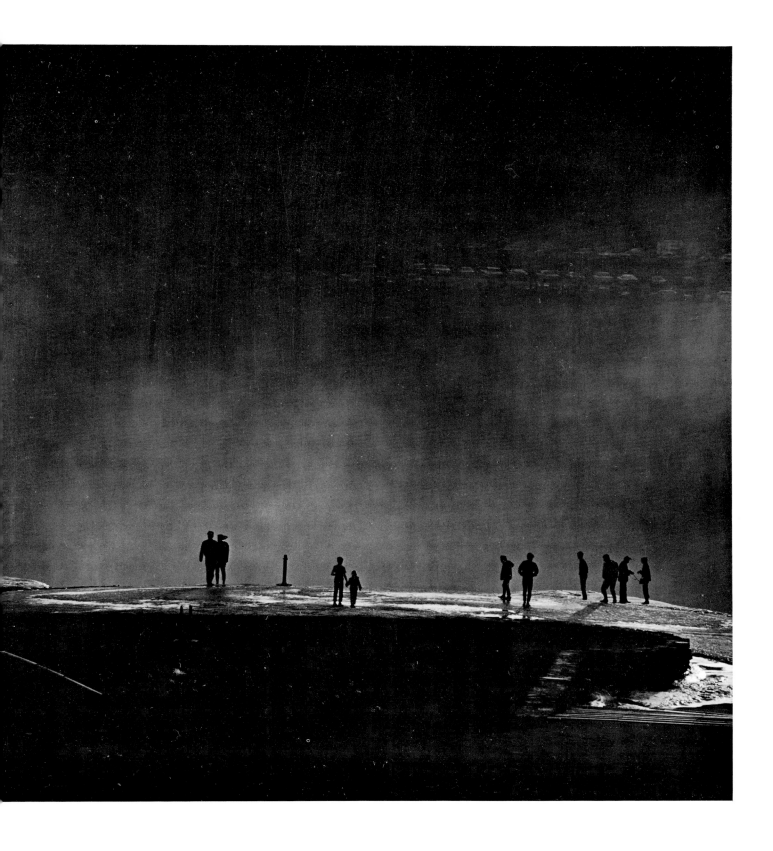

53

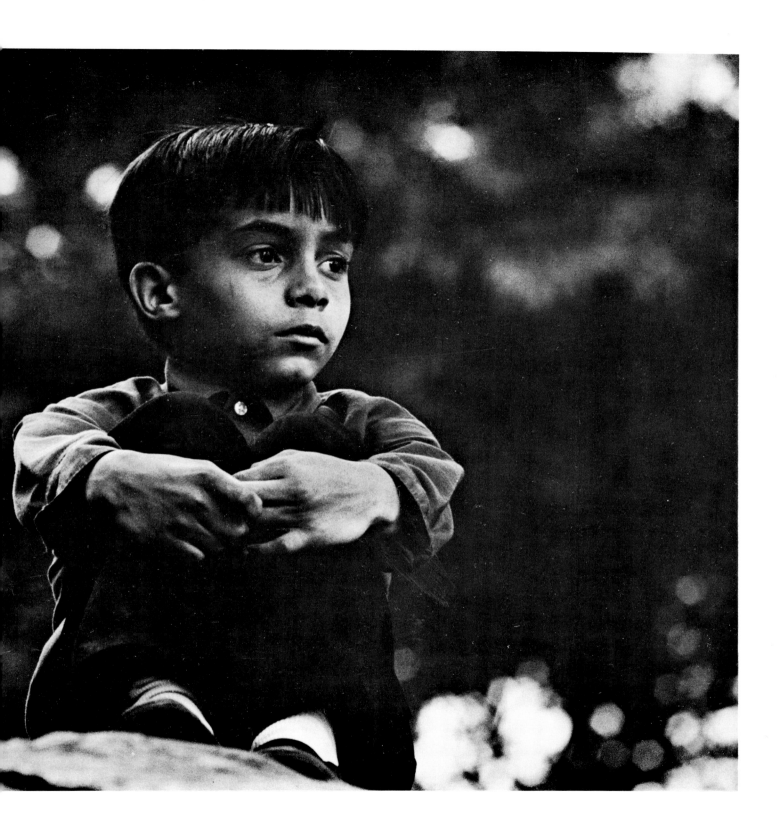

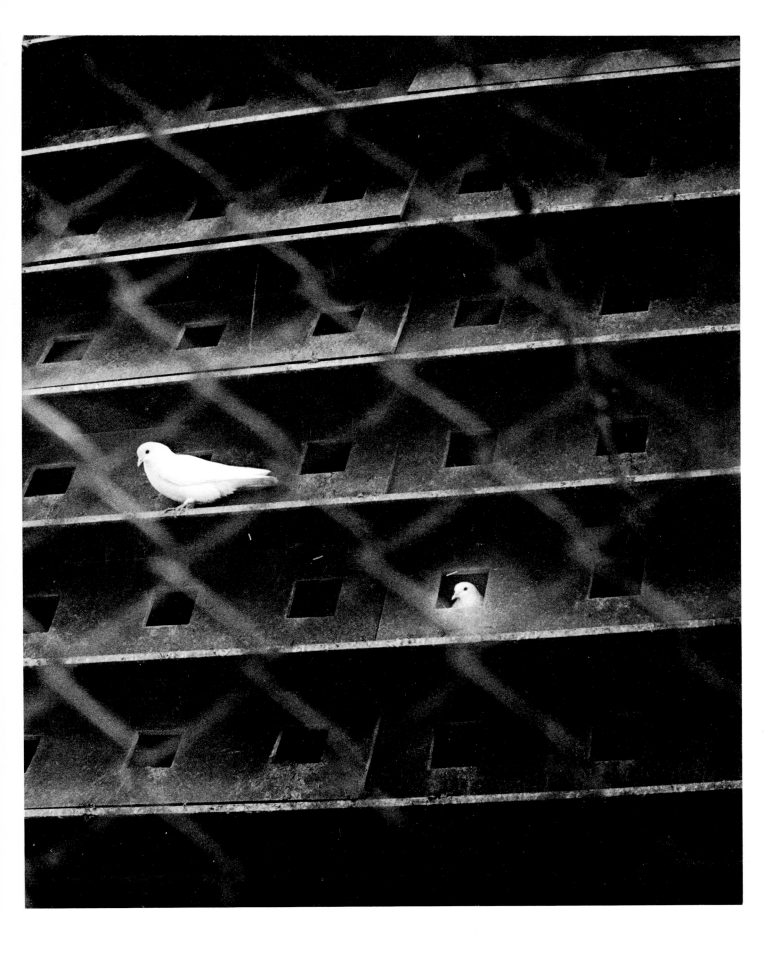

55

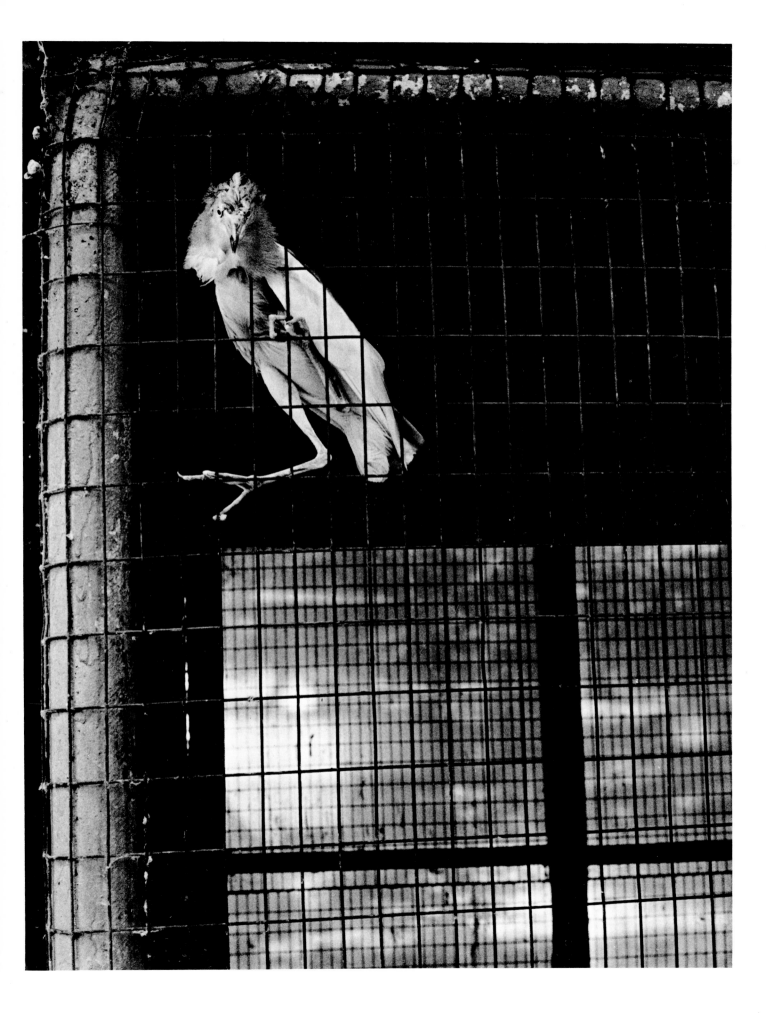

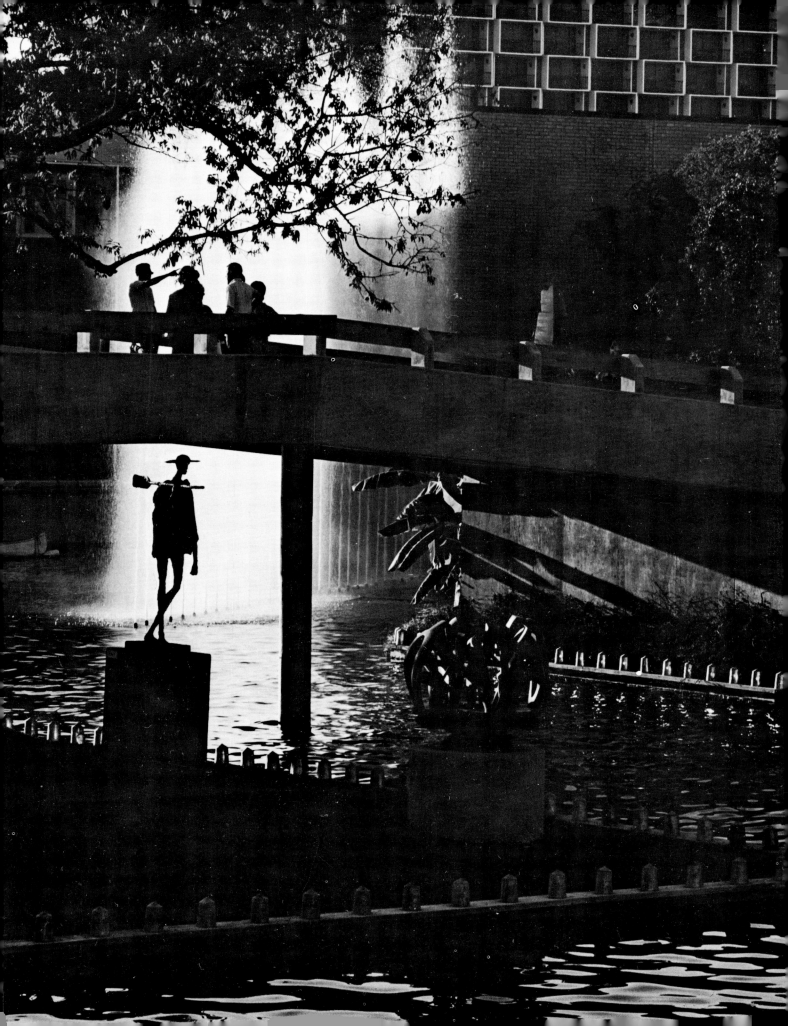

57

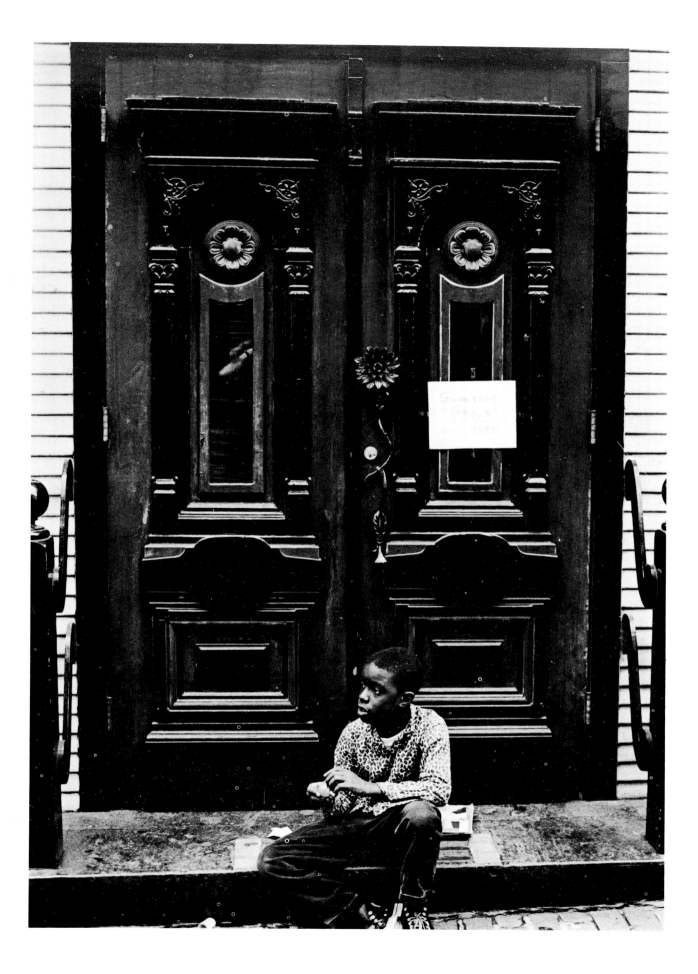

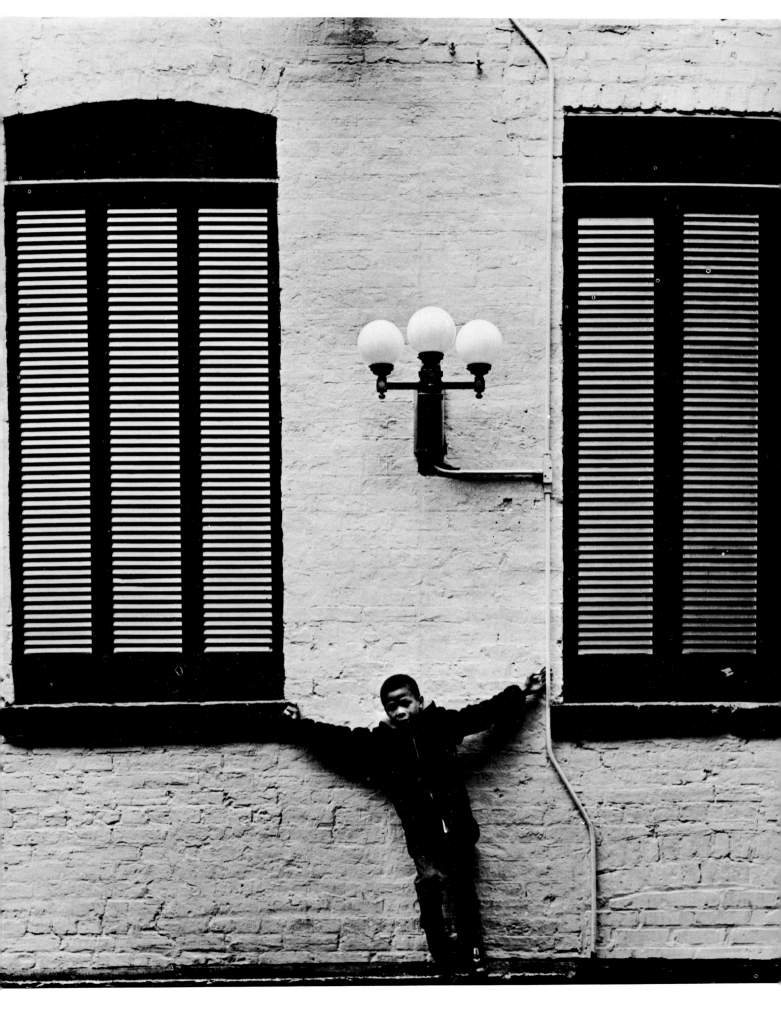

59

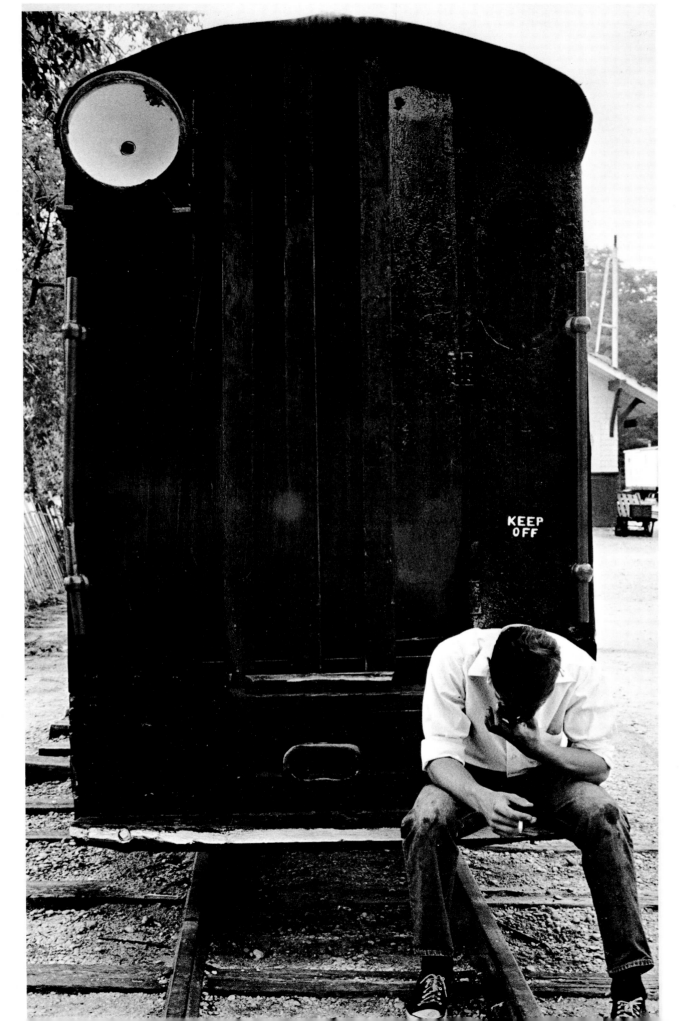

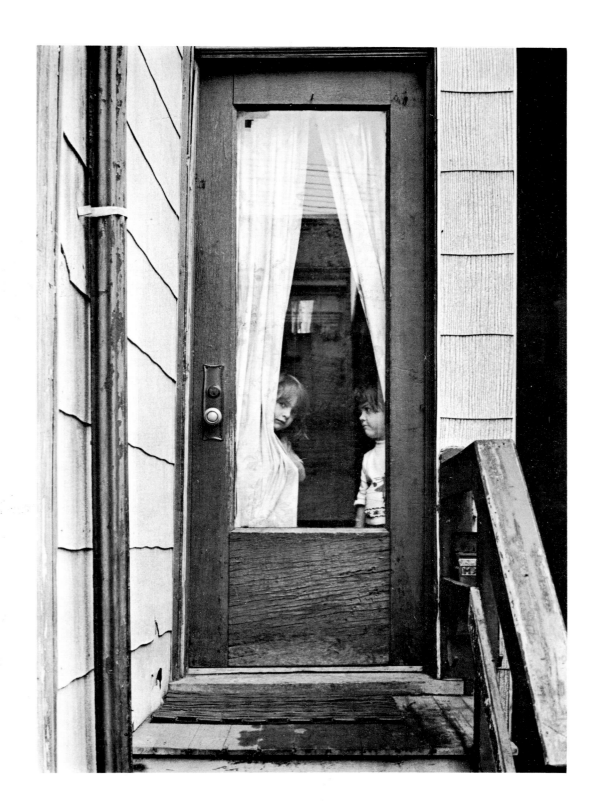

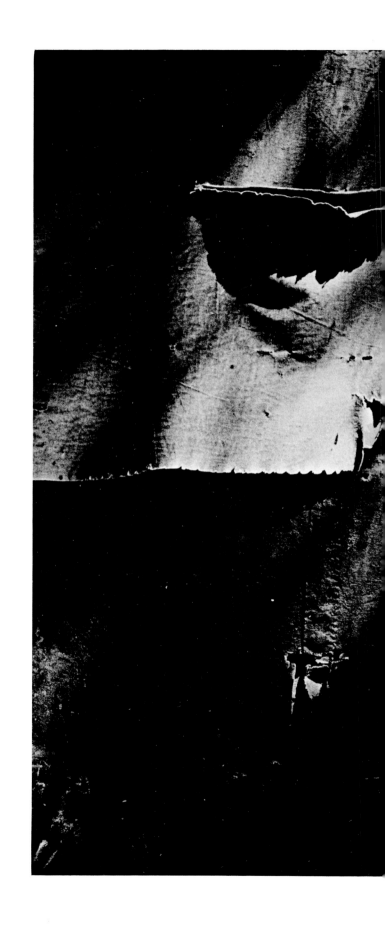

61

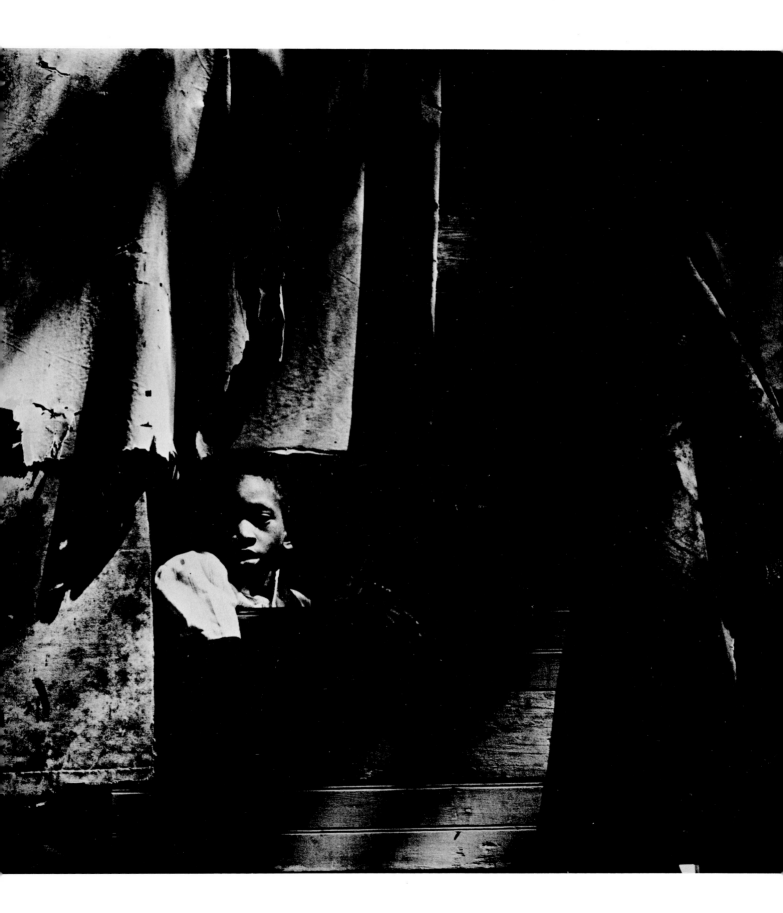

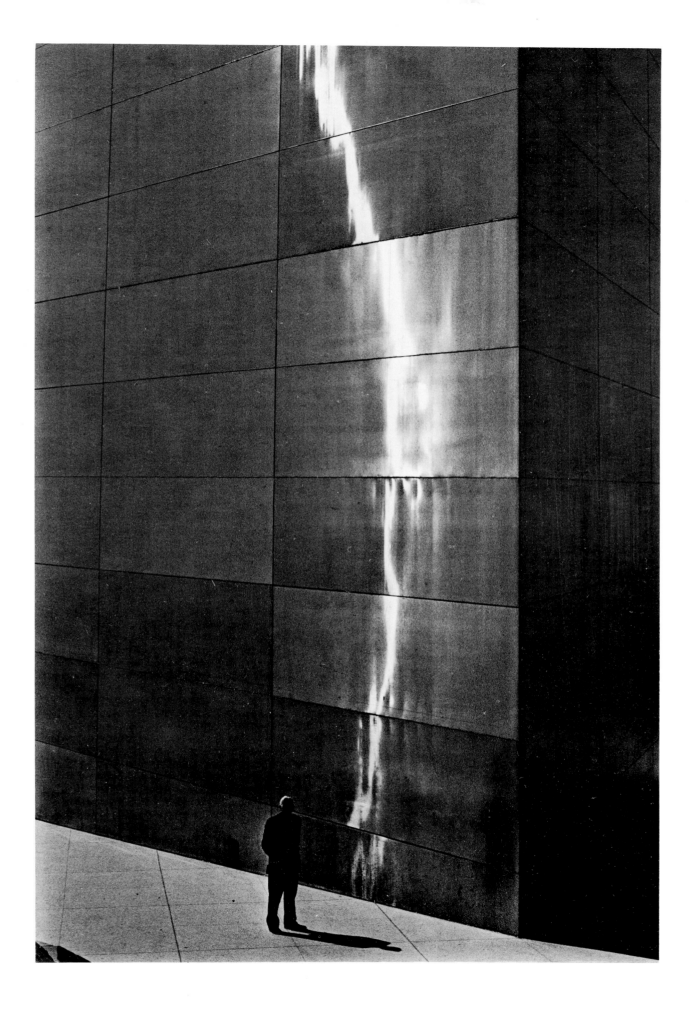

63

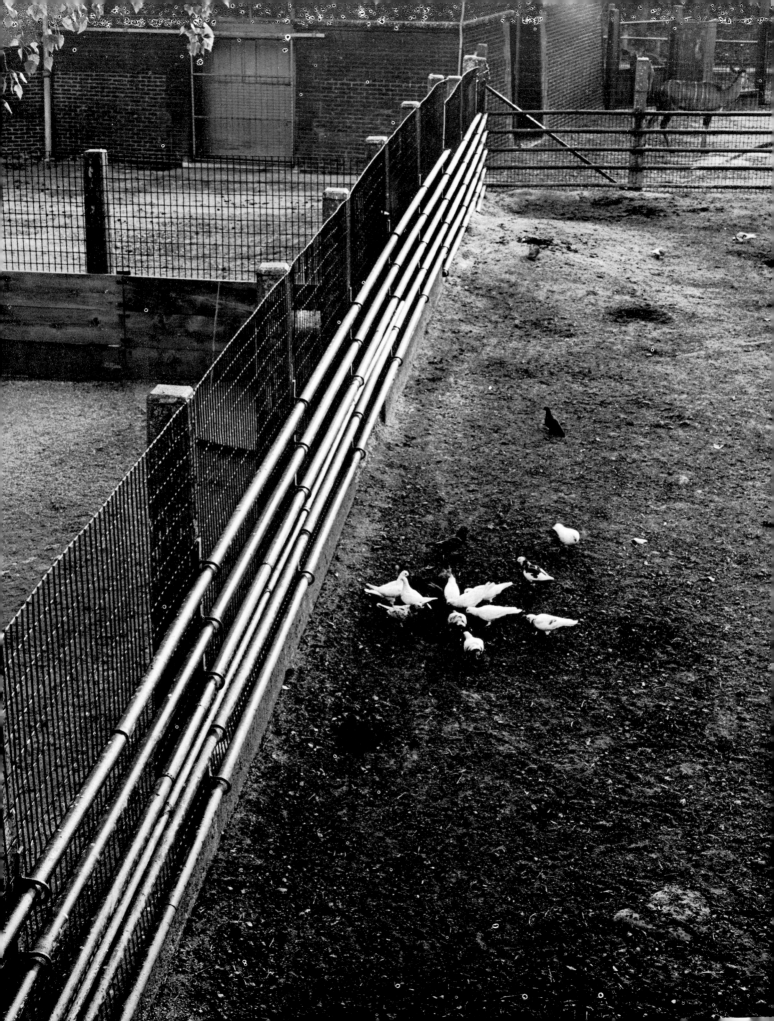

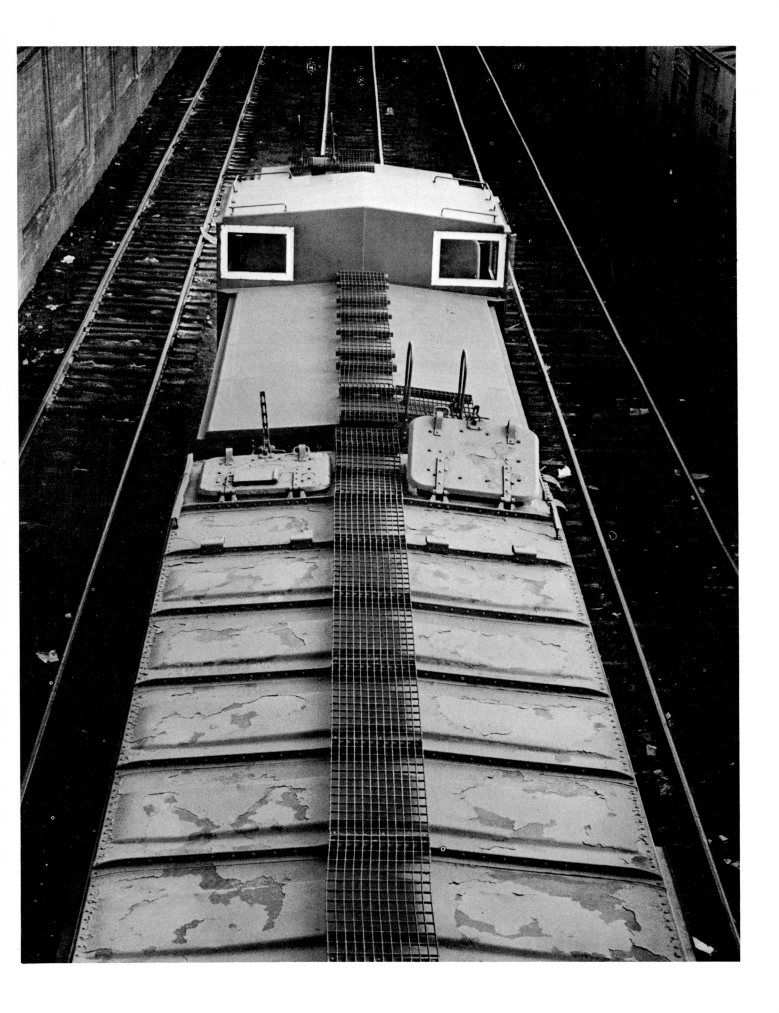